W9-APX-331

THE **ART** OF **MAP** ILLUSTRATION

A STEP-BY-STEP ARTISTIC EXPLORATION OF
contemporary cartography and **mapmaking**

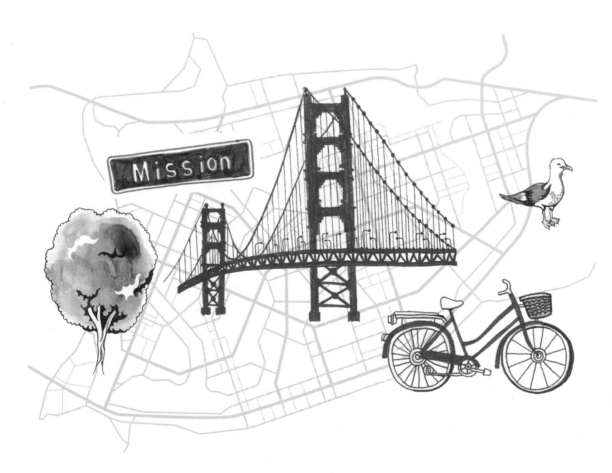

Brimming with creative inspiration, how-to projects, and useful information to enrich your everyday life, Quarto Knows is a favorite destination for those pursuing their interests and passions. Visit our site and dig deeper with our books into your area of interest: Quarto Creates, Quarto Cooks, Quarto Homes, Quarto Lives, Quarto Drives, Quarto Explores, Quarto Gifts, or Quarto Kids.

© 2018 Quarto Publishing Group USA Inc.

Artwork on front cover and pages 1, 4, and 8-39 © Hennie Haworth; back cover and pages 3 and 84-109 © James Gulliver Hancock; pages 5 and 110-143 © Sarah King; pages 40-83 © Stuart Hill; photographs on pages 6-7 © WFP; text on page 5 by Stephanie Carbajal

First Published in 2018 by Walter Foster Publishing, an imprint of The Quarto Group. 26391 Crown Valley Parkway, Suite 220, Mission Viejo, CA 92691, USA.
T (949) 380-7510 F (949) 380-7575 **www.QuartoKnows.com**

All rights reserved. No part of this book may be reproduced in any form without written permission of the copyright owners. All images in this book have been reproduced with the knowledge and prior consent of the artists concerned, and no responsibility is accepted by producer, publisher, or printer for any infringement of copyright or otherwise, arising from the contents of this publication. Every effort has been made to ensure that credits accurately comply with information supplied. We apologize for any inaccuracies that may have occurred and will resolve inaccurate or missing information in a subsequent reprinting of the book.

Walter Foster Publishing titles are also available at discount for retail, wholesale, promotional, and bulk purchase. For details, contact the Special Sales Manager by email at specialsales@quarto.com or by mail at The Quarto Group, Attn: Special Sales Manager, 100 Cummings Center, Suite 265D, Beverly, MA 01915, USA.

ISBN: 978-1-63322-484-1

Digital edition published in 2018
eISBN: 978-1-63322-485-8

Cover artwork by Hennie Haworth, *National Geographic* magazine
Cover design and page layout by Eoghan O'Brien
Acquiring and project editor: Stephanie Carbajal

Printed in China
10 9 8 7 6 5 4 3

Date: 2/20/20

526 ART
The art of map illustration : a
step-by-step artistic

THE ART OF MAP ILLUSTRATION

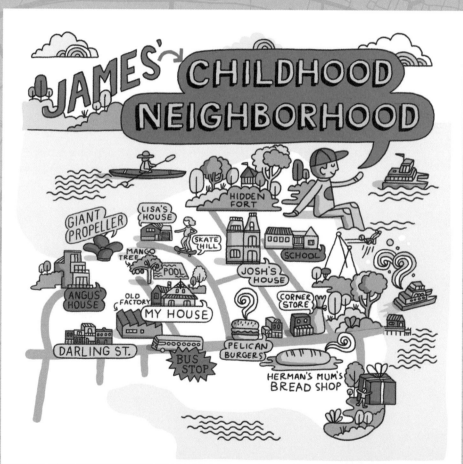

James Gulliver Hancock
Hennie Haworth
Stuart Hill
Sarah King

PALM BEACH COUNTY
LIBRARY SYSTEM
3650 Summit Boulevard
West Palm Beach, FL 33406-4198

TABLE OF CONTENTS

INTRODUCTION

Cartography is a centuries-old science and art that has captivated and informed explorers, navigators, and wanderers throughout the ages. And while cities, countries, the world, and even the universe have been thoroughly mapped (and remapped), artists and cartographers continue to make new maps of these familiar places. Why? Because a map tells a story—and everyone loves a good story.

You see, you can map more than just places. A map can share an idea or a concept, illustrate an experience, or capture a memory. It's easy to think of maps as highly technical, showing routes, distances, and topographical features. But this art form is highly interpretive, and there is endless room for creativity. You can break borders and boundaries and skew size and scale—in other words, you aren't held captive to reality.

Best of all, you can illustrate maps using any art-making supplies, from pencils and pens to paints and digital tools. In this book, you'll find inspiration and step-by-step tutorials for exploring a range of illustrated map projects and ideas. But mapmaking is a highly personal art form, so use the ideas in this book as a jumping-off point from which to discover and develop your unique style, approach, and aesthetic.

Are you ready to explore the art of map illustration? Dive in, and learn how to create contemporary, personalized artwork that captures places, moments, and memories that beg to be discovered again and again. What kind of stories will *you* tell?

TOOLS & MATERIALS

Drawing Paper Drawing paper is available in a range of surface textures (called "tooth"), including smooth grain (plate finish and hot pressed), medium grain (cold pressed), and rough to very rough. Cold-pressed paper is the most versatile and is great for a variety of drawing techniques. For finished works of art, using single sheets of drawing paper is best.

Sketch Pads Sketch pads come in many shapes and sizes. Although most are not designed for finished artwork, they are useful for working out your ideas.

Erasers There are several types of art erasers. Plastic erasers are useful for removing hard pencil marks and large areas. Kneaded erasers (a must) can be molded into different shapes and used to dab at an area, gently lifting tone from the paper.

Tortillons These paper "stumps" can be used to blend and soften small areas when your finger or a cloth is too large. You also can use the sides to blend large areas quickly. Once the tortillons become dirty, simply rub them on a cloth, and they're ready to go again.

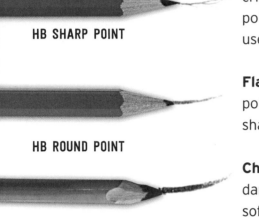

HB SHARP POINT

HB ROUND POINT

4B FLAT POINT

FLAT SKETCHING

HB An HB with a sharp point produces crisp lines and offers good control. A round point produces slightly thicker lines and is useful for shading small areas.

Flat For wider strokes, use a 4B with a flat point. A large, flat sketch pencil is great for shading bigger areas.

Charcoal 4B charcoal is soft and produces dark marks. Natural charcoal vines are even softer and leave a more crumbly residue on the paper. White charcoal pencils are useful for blending and lightening areas.

Conté Crayon or Pencil Conté crayon is made from very fine Kaolin clay and is available in a wide range of colors. Because it's water soluble, it can be blended with a wet brush or cloth.

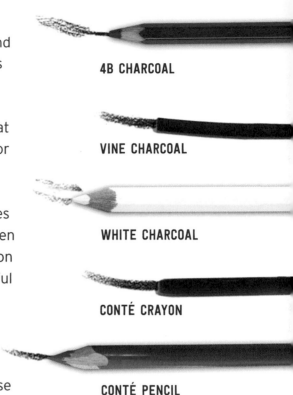

4B CHARCOAL

VINE CHARCOAL

WHITE CHARCOAL

CONTÉ CRAYON

CONTÉ PENCIL

SHARPENING YOUR PENCILS

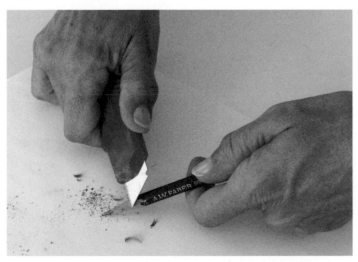

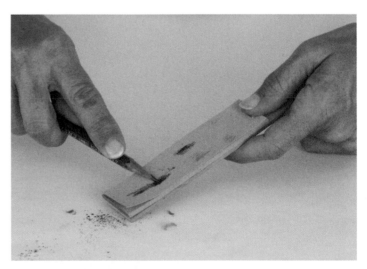

A Utility Knife Use this tool to form a variety of points (chiseled, blunt, or flat). Hold the knife at a slight angle to the pencil shaft, and always sharpen away from you, taking off a little wood and graphite at a time.

A Sandpaper Block This tool will quickly hone the lead into any shape you wish. The finer the grit of the paper, the more controllable the point. Roll the pencil in your fingers when sharpening to keep its shape even.

HENNIE
HAWORTH

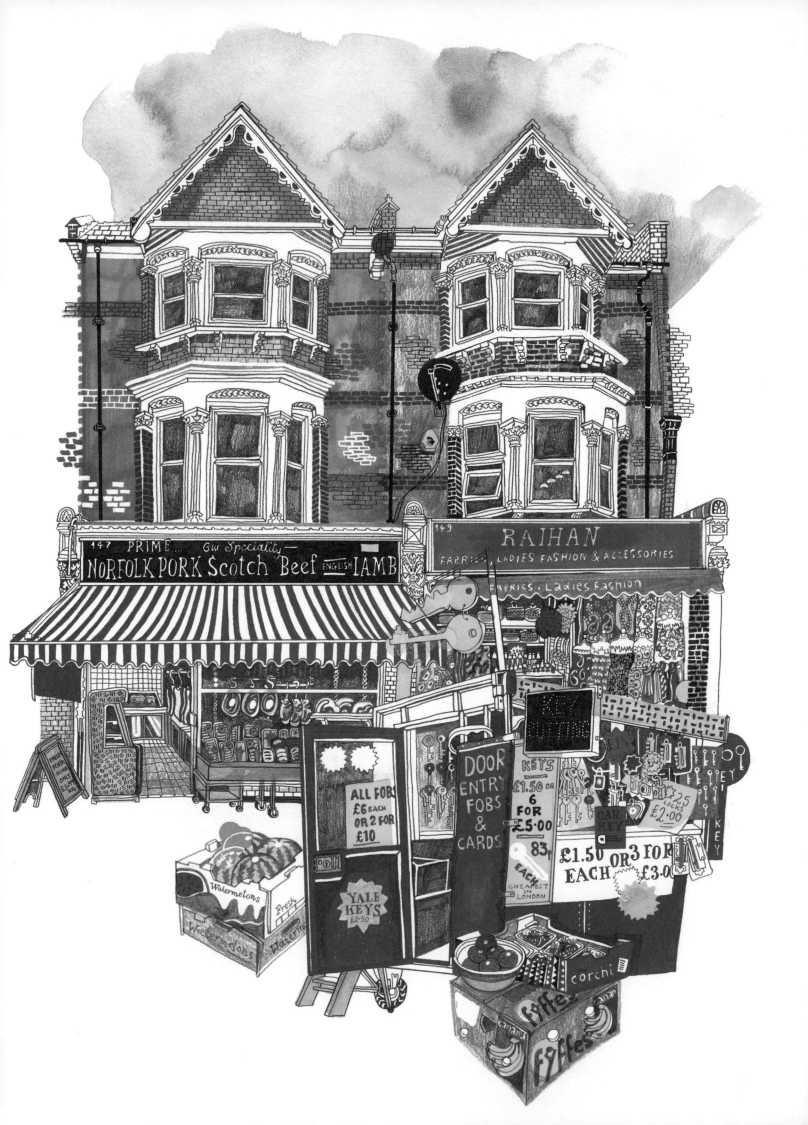

ART TOOLS

I like to use a combination of supplies for my map illustrations. Shown here are the main pens, pencils, and other items I like to use. The wonderful thing about map illustration is that you can create map art using whatever tools and materials you like best!

Markers & Highlighters

Permanent markers are great to use as a block base color. They create lovely surfaces to draw on top of with chalks or colored pencils. Highlighters can also add a bit of zing to a drawing, and they are available in a variety of tip sizes.

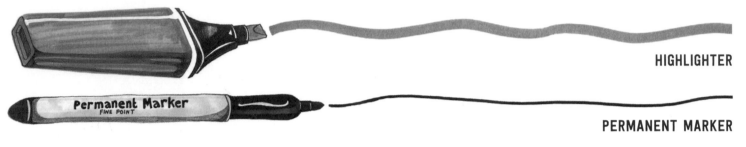

HIGHLIGHTER

PERMANENT MARKER

Pencil

A good drawing pencil is a must-have for making your beginning sketches and outlines. You can use wooden pencils or mechanical pencils that hold individual leads.

MECHANICAL PENCIL

Pens

Pens are perfect for creating smooth lines and adding bold color. Fine-tip markers work best for details and small areas, and thicker pens are perfect for larger areas of color.

THICK PEN

THIN PEN

Stickers

Experiment with using stickers in your illustration work. They can make a great base on which to draw fine details.

Watercolor

Watercolor paint is a popular choice for map art. It requires some practice to master, but its airy quality allows you to create form and color with just a few brushstrokes.

Scalpel

A scalpel or craft knife comes in handy for trimming your paper and sharpening pencils.

Colored Pencils

Colored pencils allow you to create interesting texture in your work and are another great choice for adding color.

Correction Fluid As well as for fixing mistakes, correction fluid can be used as a drawing tool to add details and highlights.

Papers There are myriad paper options to choose from. Drawing paper is available in many sizes and is great for sketching out your ideas or working in colored pencil. If you're working in marker or felt-tip pens, marker paper is the best choice to avoid bleeding and smudging. For painting with watercolors (or acrylic or gouache), use watercolor paper.

FIRST THINGS FIRST

Before beginning any illustration, you should choose the colors you need for each drawing, as well as the types of pens and pencils you'll use. Each tool produces a different kind of texture—it's nice to use them together, as the varied textures add depth to your illustration.

The tools you choose may also determine what type of paper you use to create your illustration. If you're not sure how a tool will work on your chosen surface, test it first so you can see how they work together.

MAKING A MAP

There are many things to take into consideration when it comes to making a map. If the prospect seems daunting, remember that everything can be broken down into steps. And when you work just one step at a time, you'll find that the process isn't as challenging as it may seem.

Start with the roads first, followed by buildings, trees, and any extra special features. Then consider how to label the buildings and landmarks.

ROADS & ROAD NAMES

To create an accurate map, trace the roads you want to include. Then consider how to label the roads. You might write the names on the roads, as shown here, or you can select the main roads and draw road signs, as shown on page 13. Add rivers or other areas of water with watercolor washes.

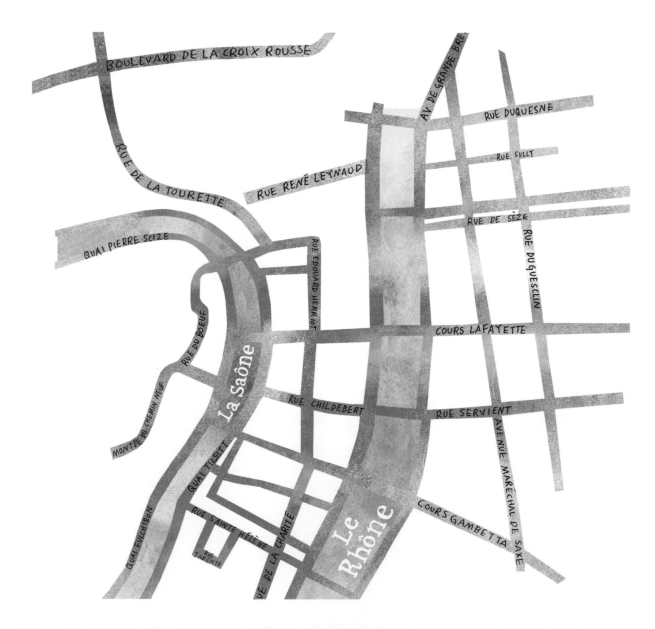

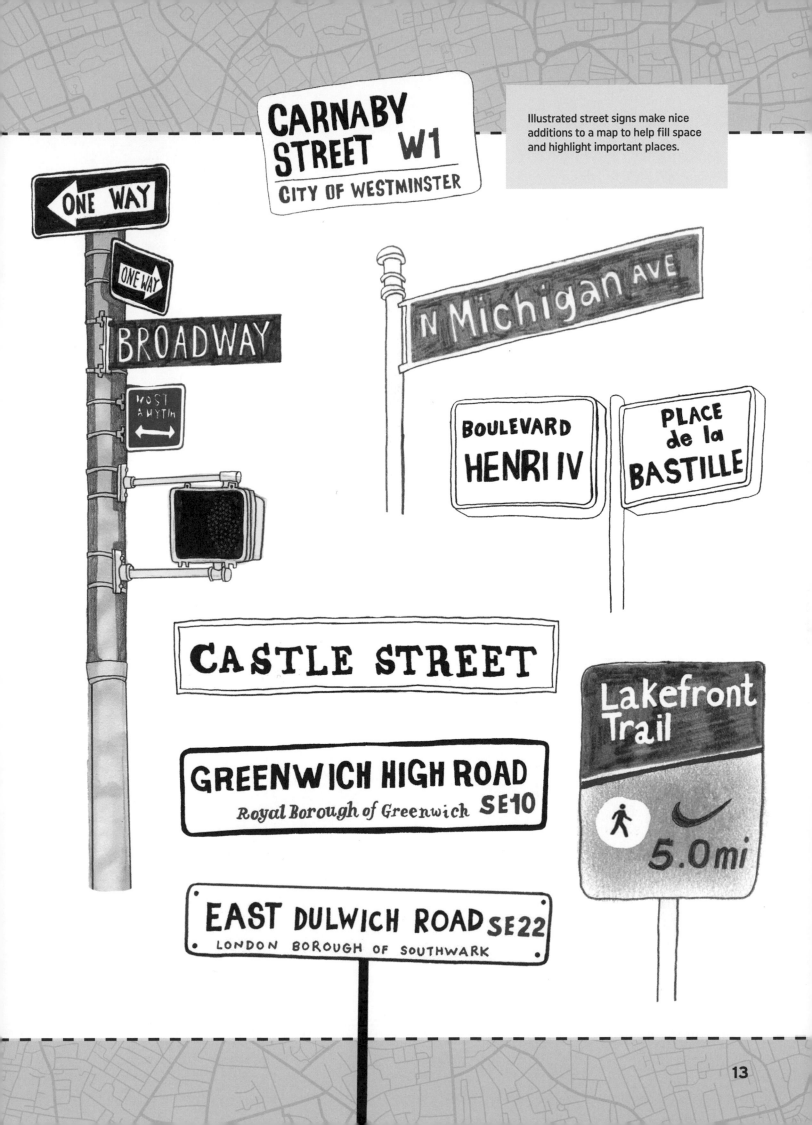

CARNABY STREET W1
CITY OF WESTMINSTER

Illustrated street signs make nice additions to a map to help fill space and highlight important places.

ONE WAY

ONE WAY

BROADWAY

MOST ANYTIM

N Michigan AVE

BOULEVARD HENRI IV

PLACE de la BASTILLE

CASTLE STREET

Lakefront Trail

5.0mi

GREENWICH HIGH ROAD SE10
Royal Borough of Greenwich

EAST DULWICH ROAD SE22
LONDON BOROUGH OF SOUTHWARK

TREES

After establishing the road, add trees to your map—
especially if it includes parks. Trees are also nice to dot
around the map and fill any gaps. Think about the types
of trees that grow in the area. Are they tropical? Or
evergreens? Palms? Oaks?

To paint trees, start with a simple blob of watercolor. Let dry,
and then use marker or pen to add branches and leaves.

1

2

3

BUILDINGS

Next choose landmarks you want to include. Make a quick sketch. Start by adding color first, followed by the details. Include logos and shop names for both visual interest and labeling.

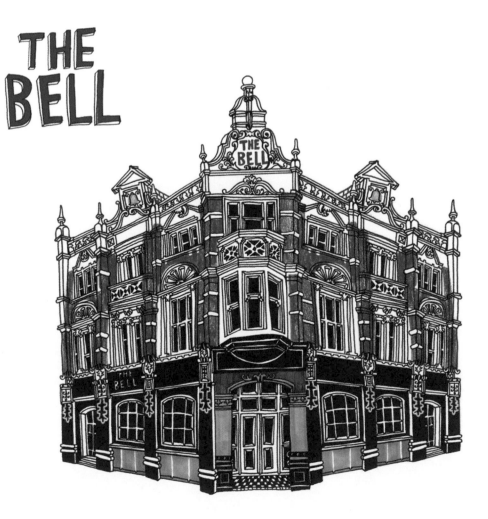

There are many types of buildings you might include in your map. You could draw shop fronts, cafés, churches, or well-known landmarks. Shown here are some examples.

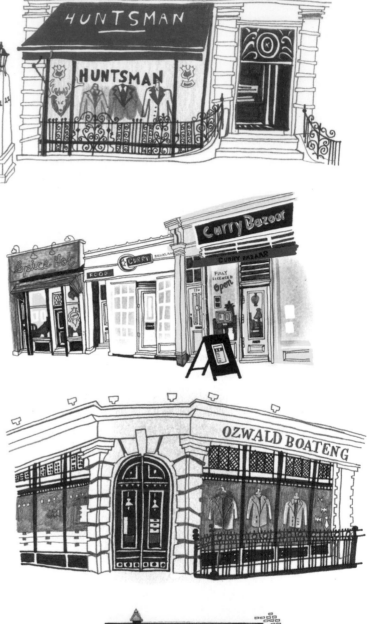

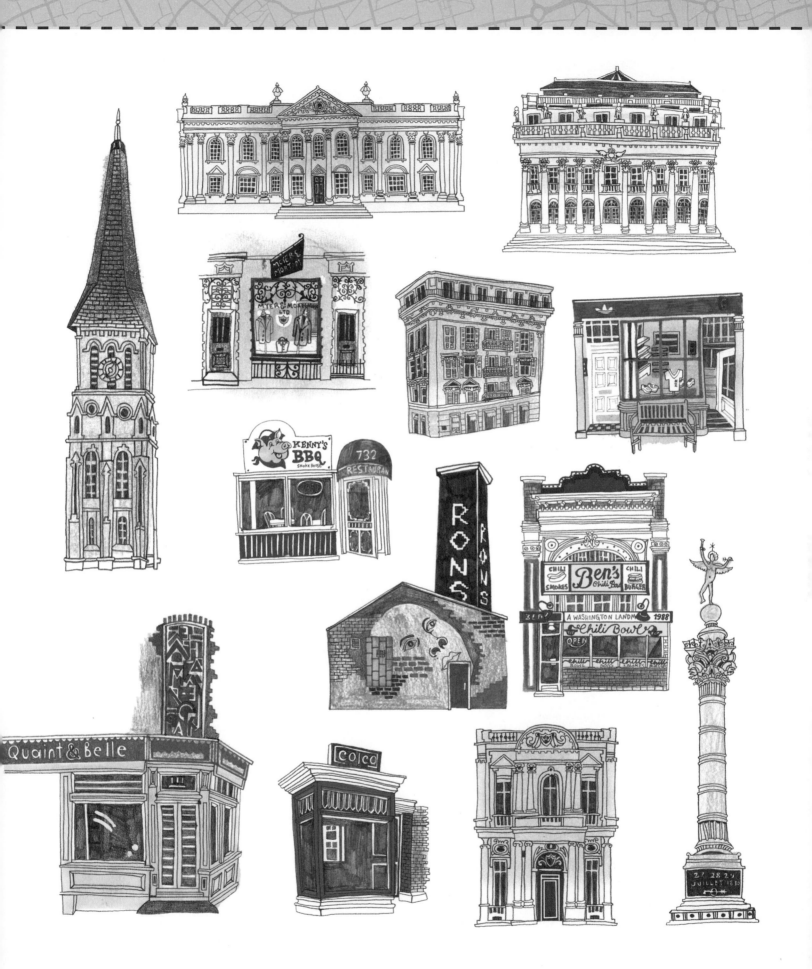

LOGOS & LANDMARKS

Drawing shop names and building logos by hand adds a whimsical touch to map illustrations. You might draw train stations as signs too. Another great way to add character is to incorporate the name into a product the building represents—a t-shirt for a clothing store, a cinema ticket for a movie theater, etc. Shown here are some examples.

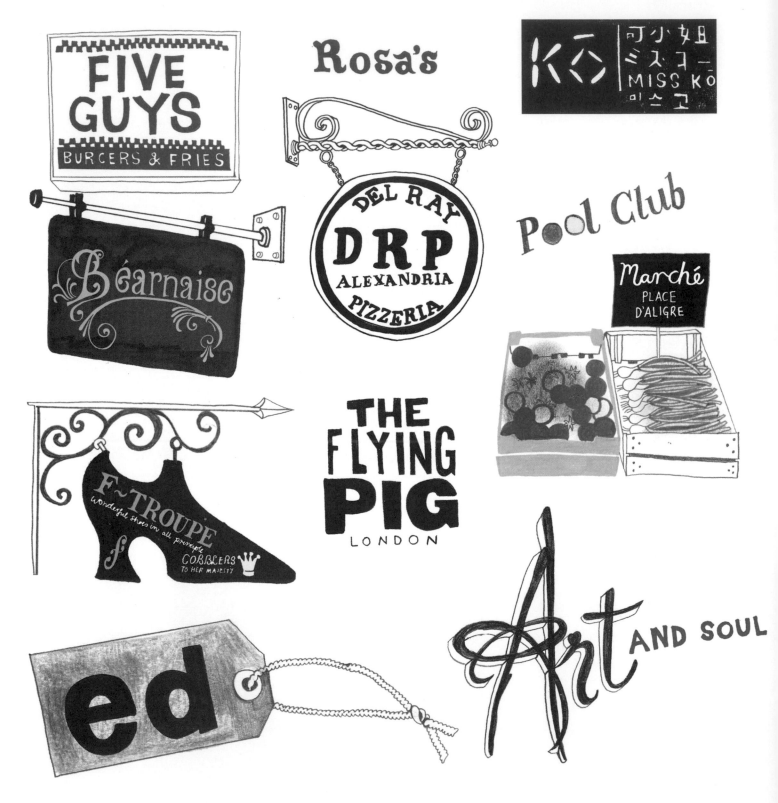

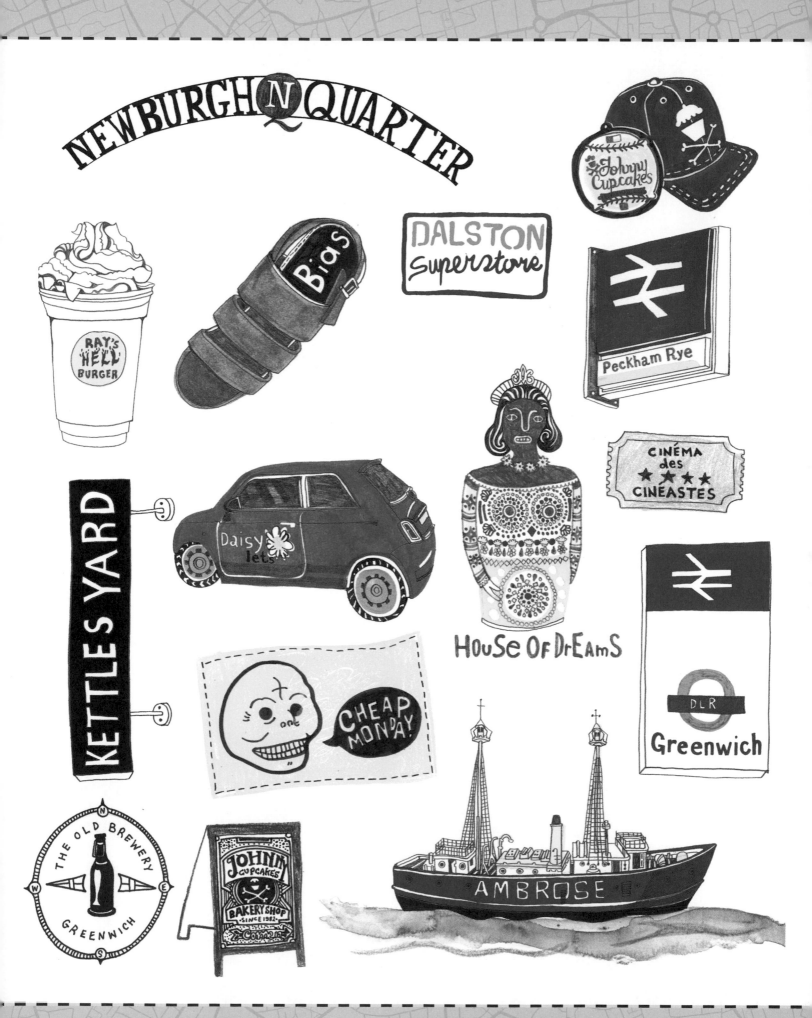

NEWBURGH N QUARTER

Johnny Cupcakes

RAY'S HELL BURGER

Bias

DALSTON Superstore

Peckham Rye

KETTLES YARD

Daisy lets

HOUSE OF DrEAMS

CINÉMA des CINEASTES

one CHEAP MONDAY

DLR Greenwich

THE OLD BREWERY GREENWICH

JOHNNY CUPCAKES BAKERY SHOP SINCE 1982

AMBROSE

SPECIAL FEATURES & EMBELLISHMENTS

To finish your map, try to brainstorm little things that are unique to the area to add to your illustration—think food, wildlife, or transport, for example. These extras can be added to fill up open areas. You could draw a cup of coffee to represent a coffee shop, or apples to depict a fruit market. Shown here are some ideas and examples.

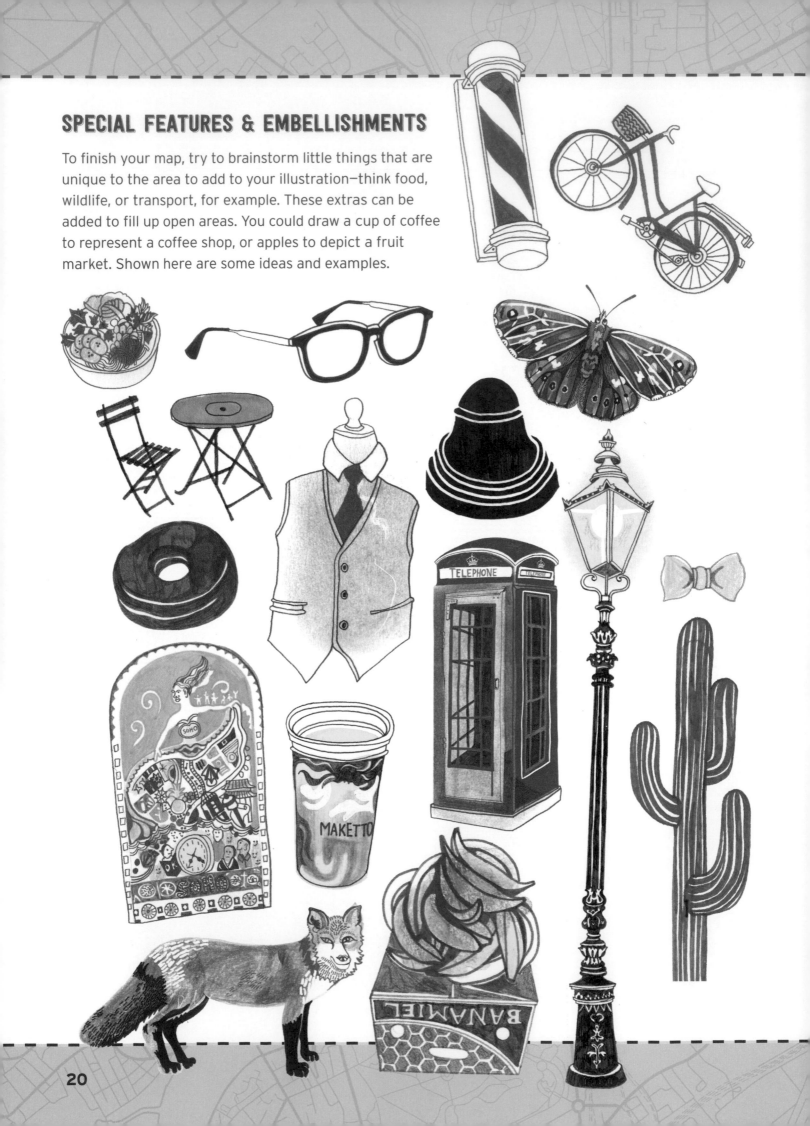

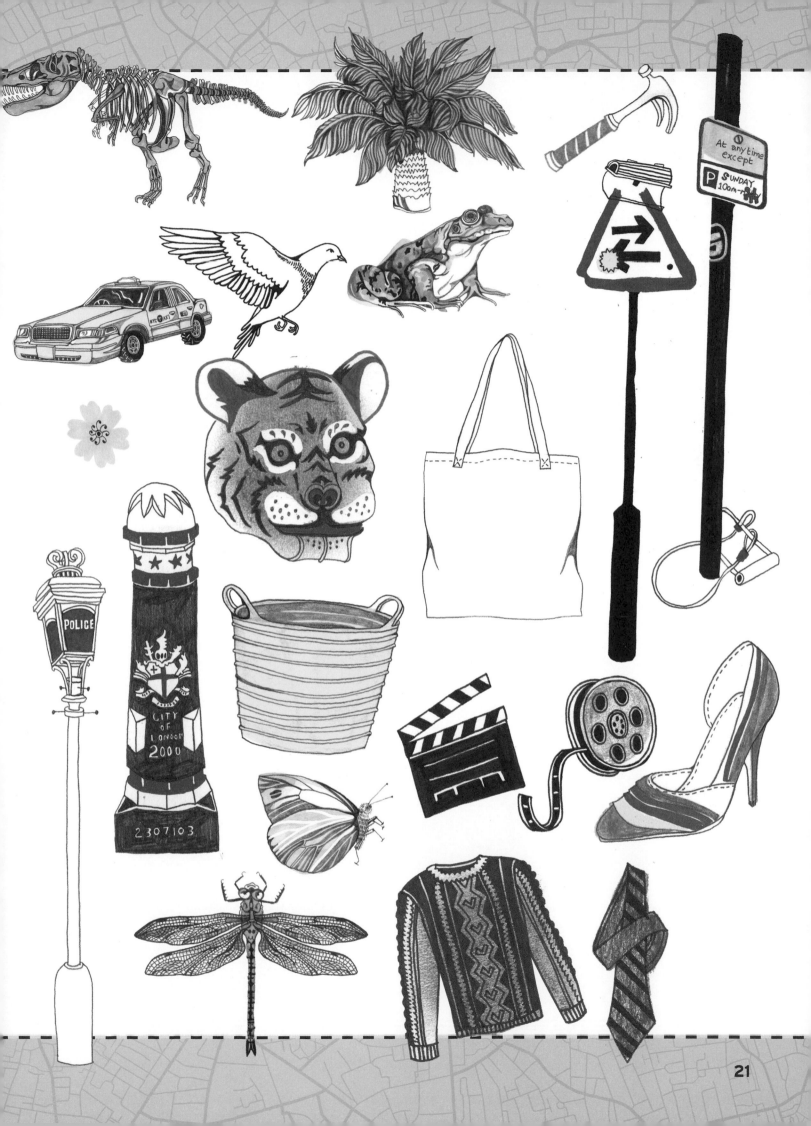

NEIGHBORHOOD MAP

When illustrating a map of a specific area, rather than a big city, you need to identify and choose landmarks and features very specific to that area. For example, this tourist map of Greenwich, one of London's boroughs on the banks of the River Thames, features restaurants, shops, and cafés unique to the neighborhood, as well as landmarks that probably wouldn't appear in a more general map of London.

First I trace the roads, and mark the main route. You might also choose to add transport at this stage. I like to draw signs to indicate transportation. I also add in the parks, and create a grassy pattern for them. I apply a watercolor wash for the section of the River Thames that appears in the map.

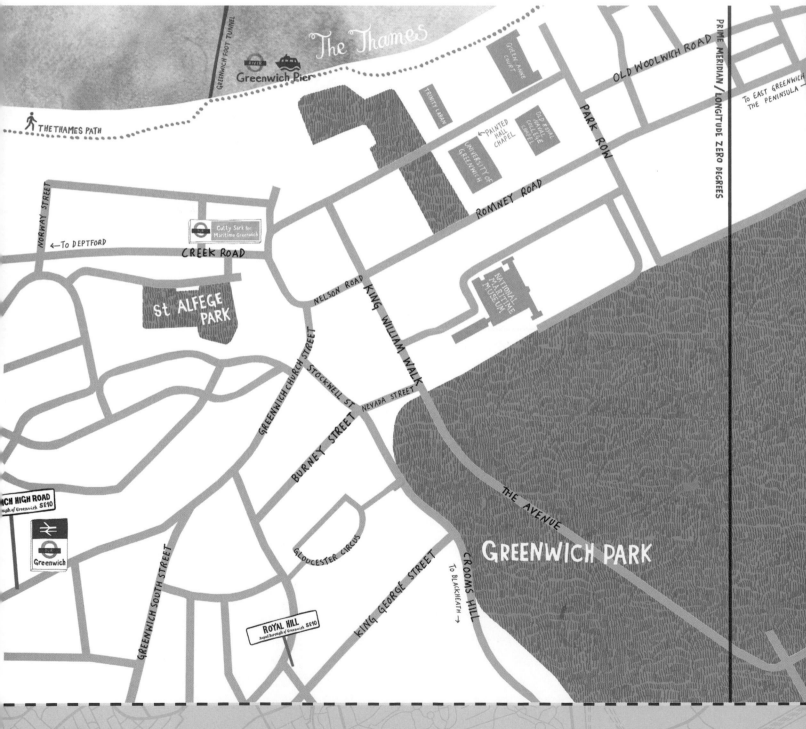

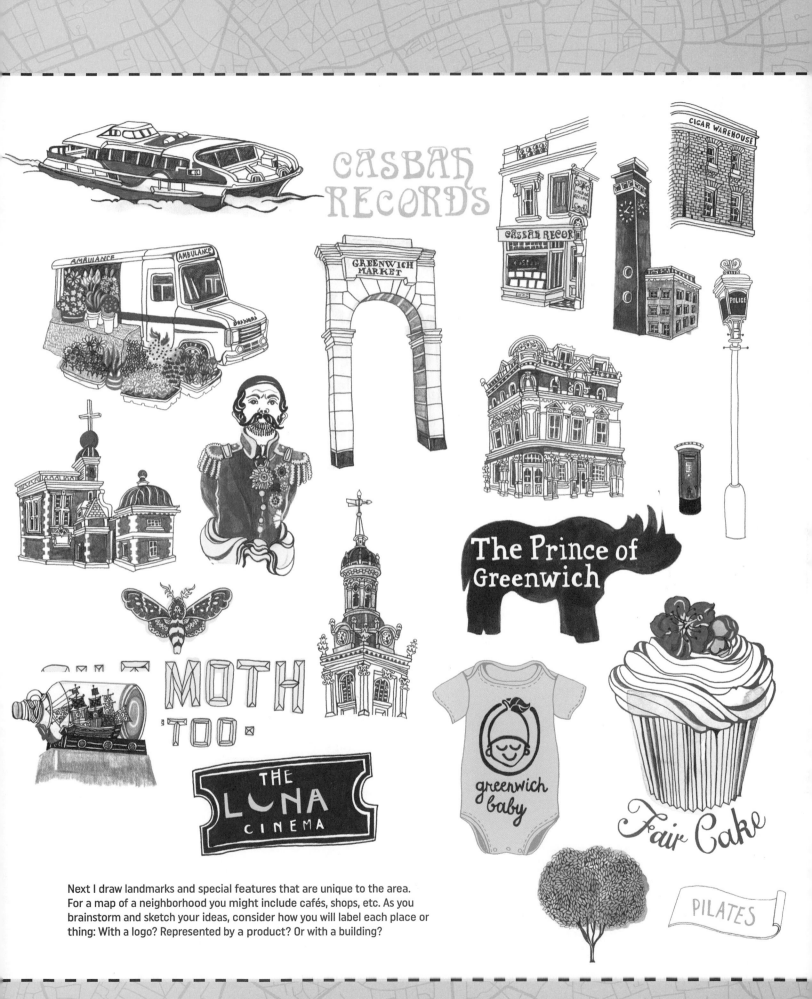

CASBAH RECORDS

GREENWICH MARKET

CIGAR WAREHOUSE

CASBAH RECORDS

AMBULANCE AMBULANCE

POLICE

The Prince of Greenwich

MOTH TOO

THE LUNA CINEMA

greenwich baby

Fair Cake

PILATES

Next I draw landmarks and special features that are unique to the area. For a map of a neighborhood you might include cafés, shops, etc. As you brainstorm and sketch your ideas, consider how you will label each place or thing: With a logo? Represented by a product? Or with a building?

Demonstrated here is a simple process for illustrating icons for your map.

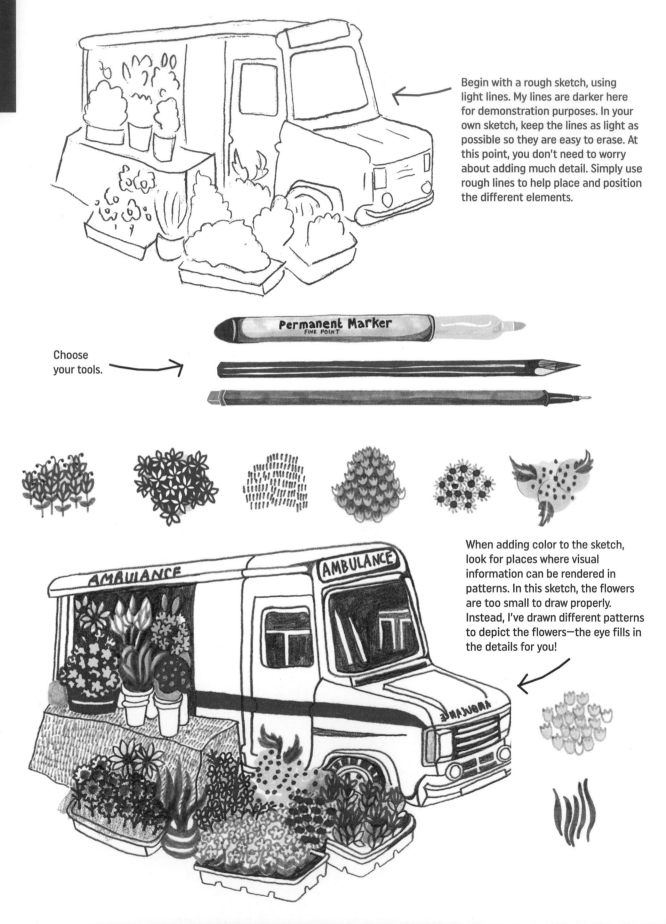

Begin with a rough sketch, using light lines. My lines are darker here for demonstration purposes. In your own sketch, keep the lines as light as possible so they are easy to erase. At this point, you don't need to worry about adding much detail. Simply use rough lines to help place and position the different elements.

Choose your tools.

Permanent Marker
FINE POINT

When adding color to the sketch, look for places where visual information can be rendered in patterns. In this sketch, the flowers are too small to draw properly. Instead, I've drawn different patterns to depict the flowers—the eye fills in the details for you!

AMBULANCE AMBULANCE

Shop logos are a nice way to fill an area with lots of texture and color.

Let the watercolor bleed for visual interest.

To draw the flower, I start with a silhouette of its shape in light pink marker. Marker ink creates a lovely base to draw on top of. Once the ink dries, I draw in details with a dark pink pen, leaving areas of highlight in the petals.

For the yellow center, I use a wax-based colored pencil, and finish by drawing fine details. When working in layers, remember to let any ink or paint completely dry before drawing additional layers on top!

Under the flower, I draw the pink frosting with a fine-tipped pink pen, and I add grooves in the cupcake wrapper with a fine-tipped black pen. I allow the yellow watercolor to bleed into the frosting for visual interest and to help connect the two parts of the cupcake. Lastly, I add the shop's name!

Fair Cake

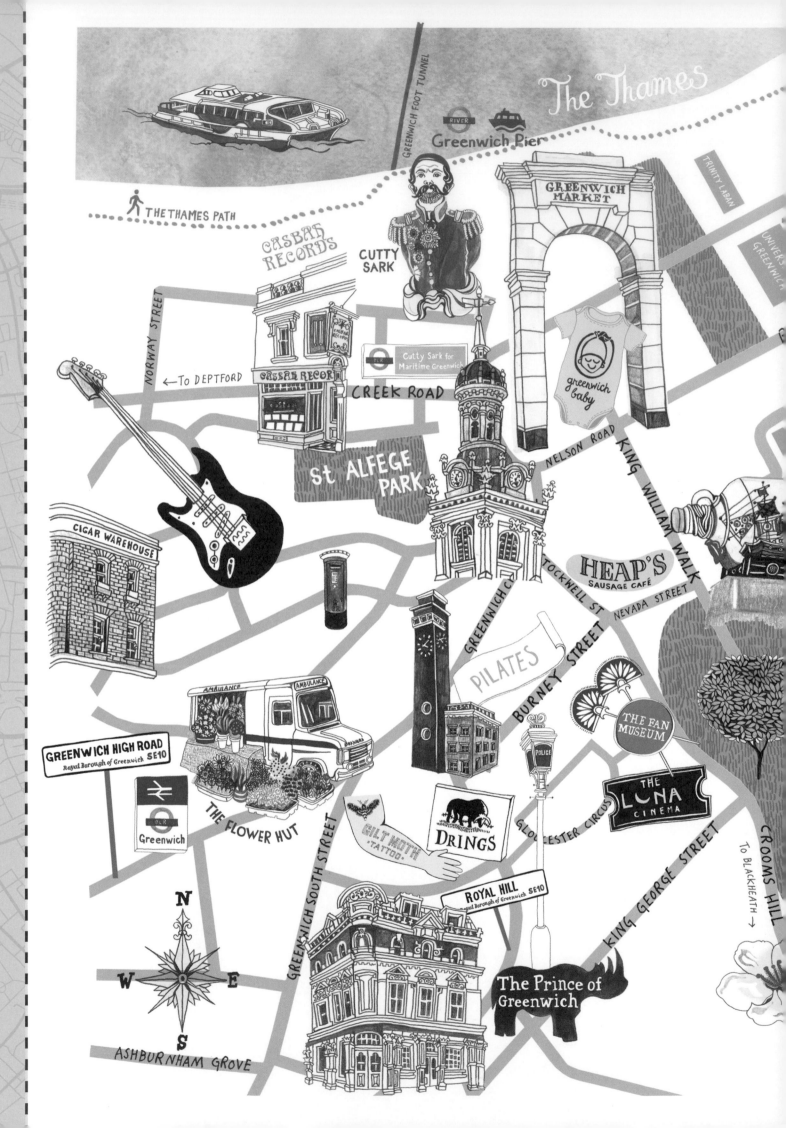

The Thames

Greenwich Foot Tunnel

RIVER Greenwich Pier

THE THAMES PATH

CASBAH RECORDS

CUTTY SARK

GREENWICH MARKET

TRINITY LABAN

UNIVERS GREENWICH

NORWAY STREET

← TO DEPTFORD

Cutty Sark for Maritime Greenwich

CREEK ROAD

greenwich baby

St ALFEGE PARK

NELSON ROAD

KING WILLIAM WALK

CIGAR WAREHOUSE

HEAP'S SAUSAGE CAFÉ

GREENWICH C STOCKWELL ST

NEVADA STREET

PILATES

BURNEY STREET

THE FAN MUSEUM

AMBULANCE AMBULANCE

POLICE

THE LUNA CINEMA

GREENWICH HIGH ROAD SE10
Royal Borough of Greenwich

Greenwich

THE FLOWER HUT

GREENWICH SOUTH STREET

GILT MOTH TATTOO

DRINGS

GLOUCESTER CIRCUS

ROYAL HILL SE10
Royal Borough of Greenwich

KING GEORGE STREET

CROOMS HILL

To BLACKHEATH →

N
W E
S

The Prince of Greenwich

ASHBURNHAM GROVE

Fair Cake OLD WOOLWICH ROAD

PARK ROW

OLD ROYAL NAVAL COLLEGE CHAPEL

ROAD

THE QUEEN'S HOUSE

PRIME MERIDIAN / LONGITUDE ZERO DEGREES

To East Greenwich & the Peninsula →

AVENUE

ENWICH PARK

Royal Observatory

If you're working by hand, create one logo and special feature at a time. If you'd like to have more freedom, complete each special icon, logo, and feature on paper, and scan all the artwork into your computer. By separating and cropping the individual features, you can resize images and adjust their placement on the map using your favorite photo-editing software.

URBAN MAP

This map of San Francisco features a larger area, so I want to include main roads and more general landmarks. Larger city maps like this are less accurate than detailed neighborhood maps. While not the right kind of map for getting around, it offers a nice overall impression of an area—and it makes for beautiful artwork for prints, stationery, and other paper goods and gifts!

As usual, I begin by drawing the shape of the area. Then I add the main roads and label them. If there is water, apply color in the appropriate area. I always use a watercolor wash!

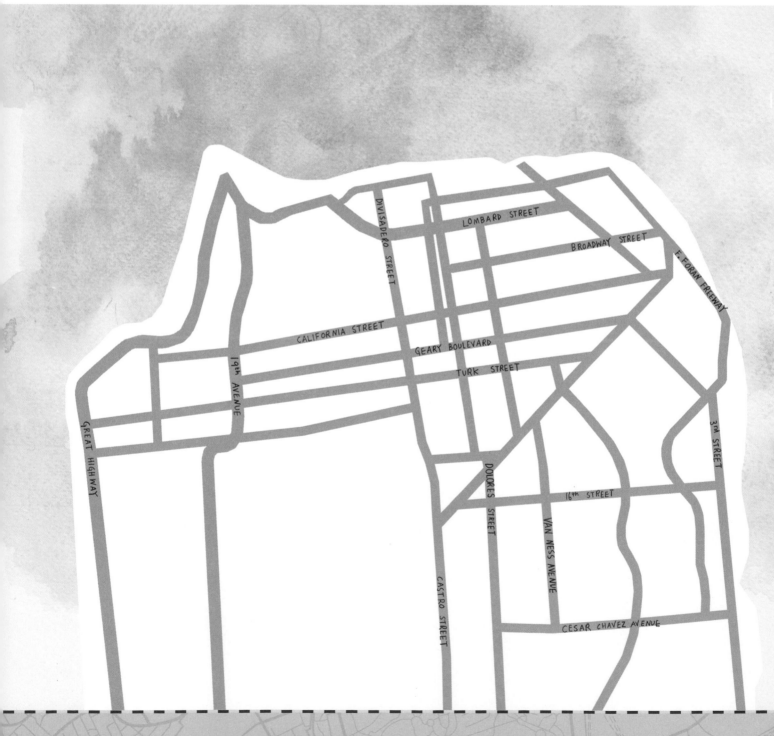

Next I draw all the icons, buildings, logos, and features that are well-known in the area! Shown here are some of my illustrations for this map of San Francisco.

For each illustration, remember to start with a light pencil sketch, apply color with the tools of your choice, and erase any pencil lines. Keep in mind that you don't need to include every minute detail. A few well-placed lines and patterns create the illusion of texture and shading.

PIER 39 PIER 39

CITY LIGHTS

CITY LIGHT POOR

UNION SQUARE

SAN FRANCISCO

JACK KEROUAC
ADLER

TWIN PEAKS

CASTRO

FISHERMANS. WHARF.

FRISGO TATT

TATTOO

Follow these easy steps to draw Alcatraz and Cliff House. For both of these iconic landmarks, I start by creating the main area with a simple blob of watercolor. Both buildings perch on large rocks and cliffs, and watercolor is a great medium for rendering organic shapes. Create color variation and texture by adding drops of additional paint colors and allowing them to bleed into each other.

Let the paint dry completely before working on top of it. Once dry, I draw the building on top of the rocks in pencil first. I also use gray felt-tip pen on the tower of Alcatraz.

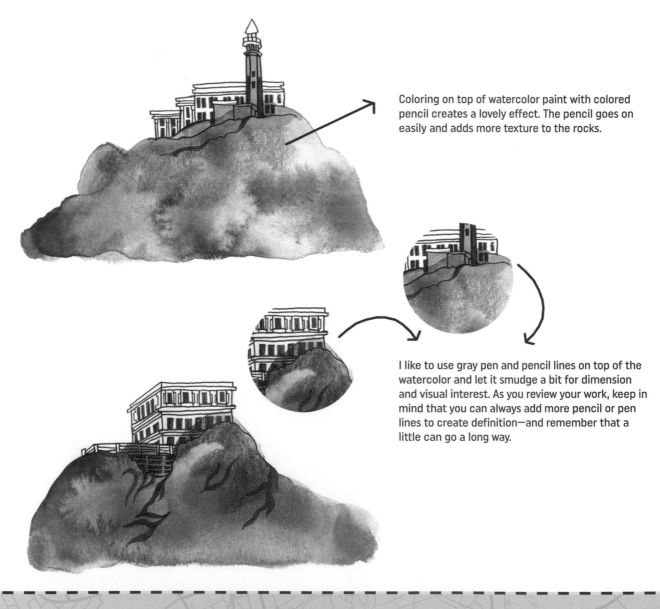

Coloring on top of watercolor paint with colored pencil creates a lovely effect. The pencil goes on easily and adds more texture to the rocks.

I like to use gray pen and pencil lines on top of the watercolor and let it smudge a bit for dimension and visual interest. As you review your work, keep in mind that you can always add more pencil or pen lines to create definition—and remember that a little can go a long way.

Buildings are a great way to fill extra space in any map. I love the angle of these shops in the Mission neighborhood. Corner shops are perfect for showcasing a unique angle, especially if the building has a lot of character or texture, like the brick pattern on the side of these shops. This building also features fun type on the front and lovely, colored awnings.

First I sketch the building in pencil.

Then I select pens and pencil for color.

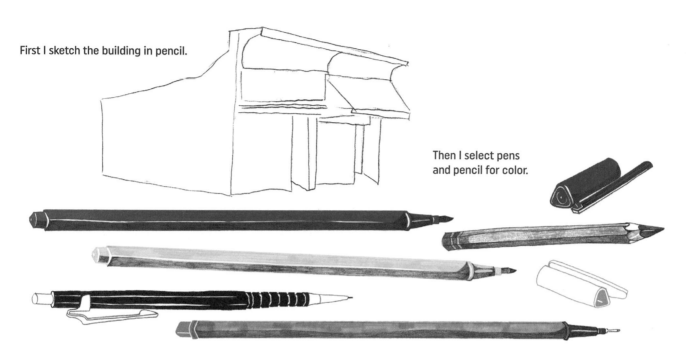

I block in base colors first. Consider mixing up your materials, and don't be afraid to use more than one type of pen or pencil. I love this combination of colored pencil, thick red pen, and thin, scratchy blue pen. All the different marks work well together and create lots of texture and variation.

Overlay colors, as shown here to create dimension. Once I add the brick detail on top, this mark adds depth to the brick wall.

I finish by drawing all the finer details with pencil and fine felt-tip pens, including the shop name. I use pencil to add a few bits of shading on top of the felt-tip pen, as shown here.

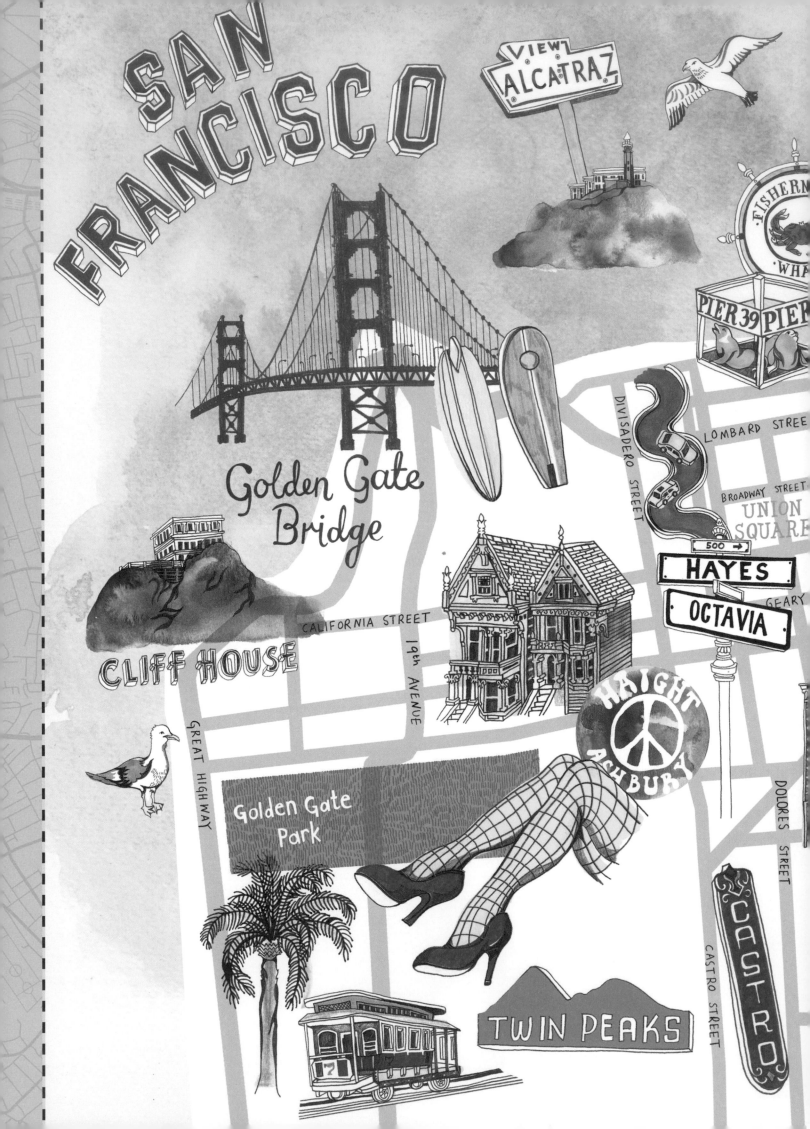

If you're working by hand, work on one feature at a time. If you prefer to work digitally, create each illustration and scan them in to your computer. You might have to resize some of the icons to fit. But remember that this isn't a really accurate map—it's a visual overview—so don't worry too much if things aren't in the exact right place!

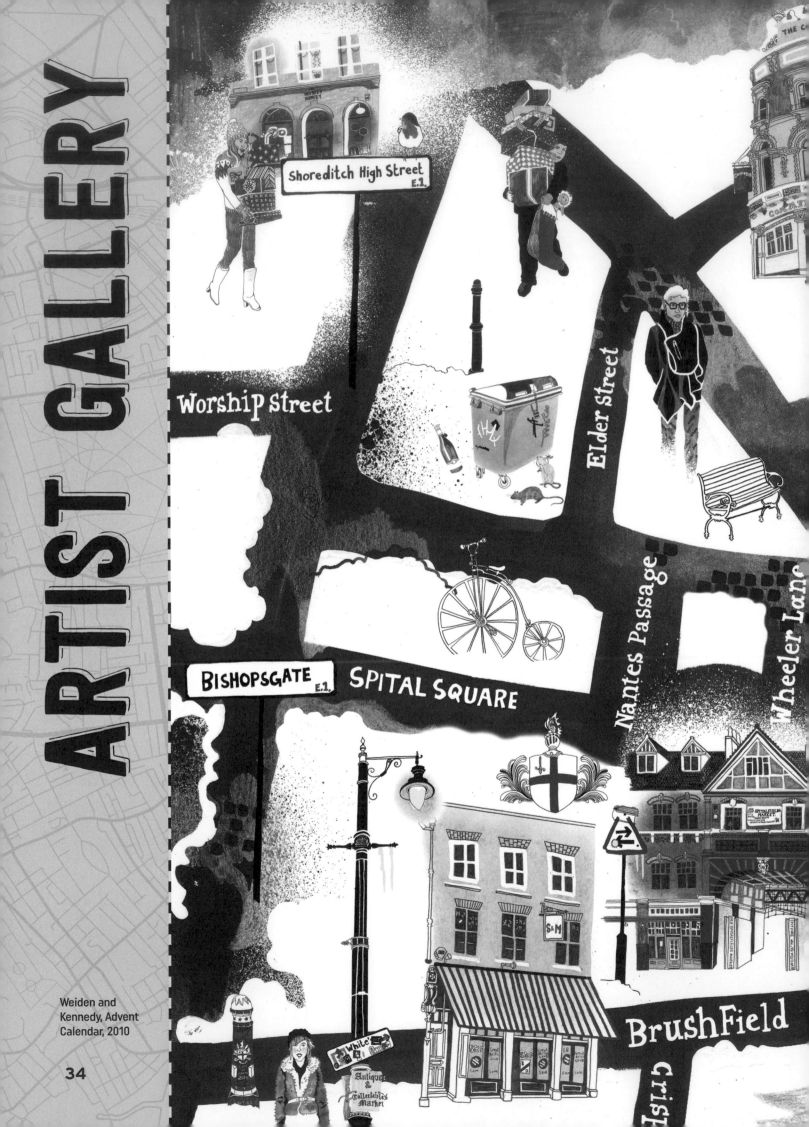

Weiden and
Kennedy, Advent
Calendar, 2010

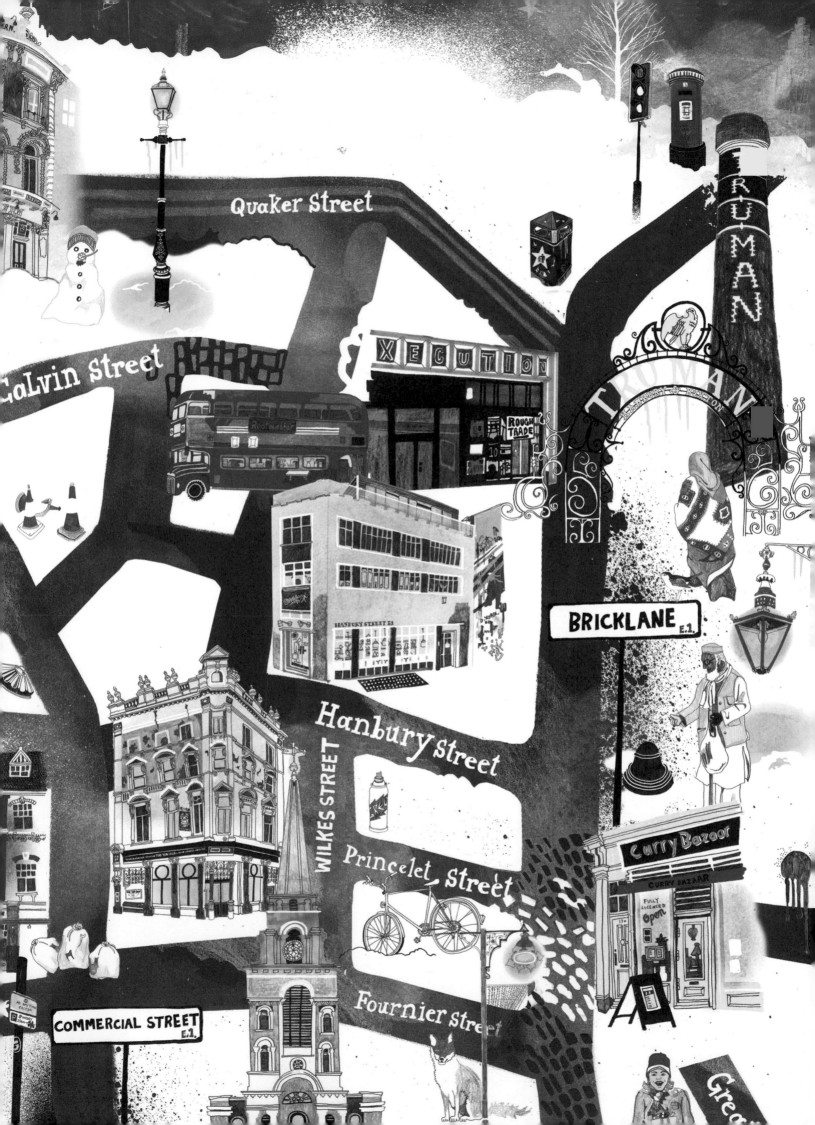

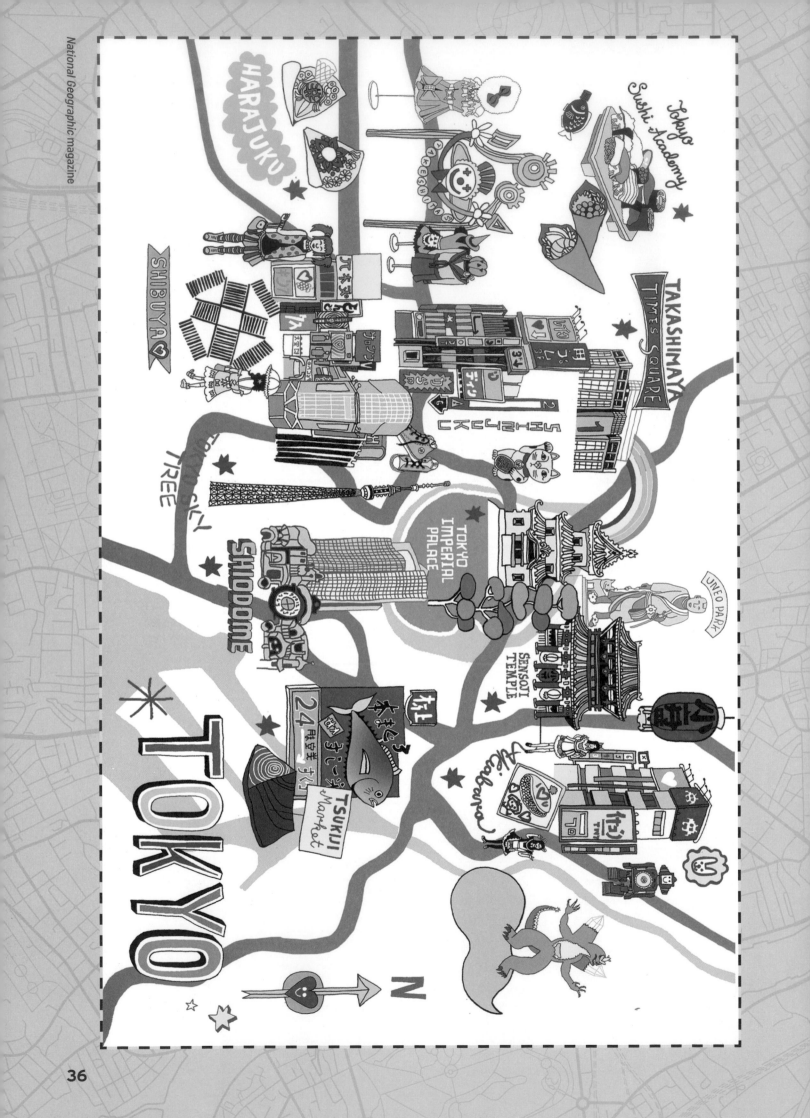

Washingtonian magazine, 2017

Paris

MOULIN ROUGE

Montmartre

Musée Jacquemart - André

Musée de CHASS de la NAT

MARAIS

RUE DES MARTYRS

AVENUE DES CHAMPS-ÉLYSÉES

Palais Royale

Palais de Tokyo

Musée Rodin

Nôtre-D

The Latin Quarter

Tour Montparnasse

Institut du Monde Arabe

GQ magazine

STUART
HILL

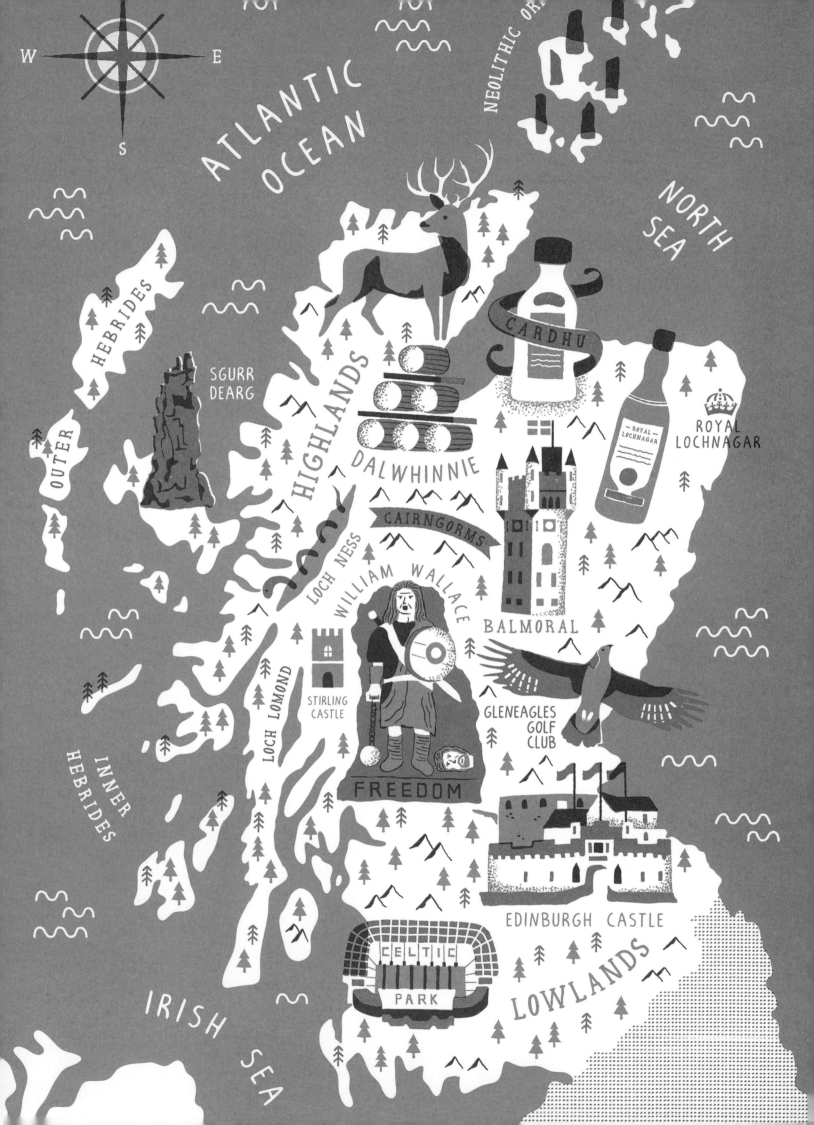

DIGITAL TOOLS

I create almost all of my maps using a combination of traditional and digital tools. Working digitally gives you lots of creative freedom to make changes as you go and explore different effects and techniques. With software like Adobe® Photoshop® and Illustrator®, you can even create a hand-rendered look for your maps.

The best thing about working digitally is that your computer is like a jam-packed artist's cupboard, without all the mess! I encourage you to never stop playing with different tools, effects, and ways of combining digital and handmade elements. There are many, many buttons in my digital illustration programs that I have yet to press. I never seem to make something the same way twice—and that's one of the exciting things about working digitally!

These pages offer a very brief overview of some of the tools and effects I use for digital map illustration, and it barely scratches the surface of the capabilities of these powerful programs.

TOOLS

If you're interested in exploring digital illustration techniques, you'll need the following tools:

- Scanner
- Computer
- Image-editing software, such as Photoshop
- Vector-editing software, such as Illustrator
- Digital drawing tablet (optional)

WORKING WITH PHOTOSHOP

Pen Tool There are several pen tool options available in Photoshop. The standard pen tool is best for drawing straight segments or very precise curves. The freeform pen tool allows you to draw just like you would with a pen or pencil on paper.

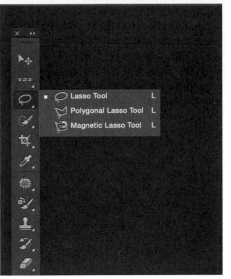

Lasso Tool Use the lasso tool to select a portion of your image. With the standard lasso tool, you can draw around the selected area freehand. The polygonal lasso tool is a good option for a straight-edged selection. The magnetic lasso tool "snaps" the border to the edge of a defined area.

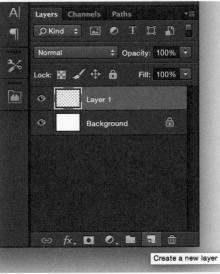

Layers Panel The layers panel in Photoshop lists all the layers in your file. You can show and hide layers by clicking on the eye icon to the left of each layer. To create a new layer, click on the square icon at the bottom of the panel that has a corner folded up. It's a good idea to keep your items on separate layers when working in Photoshop, so that you can move, resize, and add texture to specific layers without affecting the entire image.

WORKING WITH ILLUSTRATOR

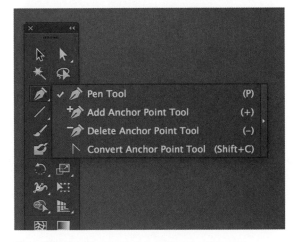

Pen Tool Like Photoshop, Illustrator's pen tool allows you to outline and fill shapes quickly with very clean, precise edges.

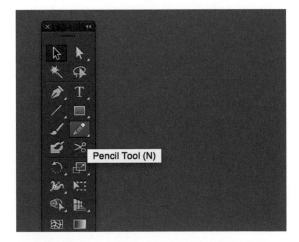

Pencil Tool The pencil tool works well for drawing imprecise shapes. Rather than using many anchor points, like the pen tool, you can draw a whole shape in practically one motion.

Paintbrush Tool The paintbrush tool is similar to the pencil tool, allowing you to click and drag on the screen to draw. To open the brush panel shown here, navigate to the "Window" dropdown menu in Illustrator, and select "Brushes" from the list. Use the options in the panel to change the way your brushstrokes look. You can also apply a brushstroke to an existing path; simply select the path (or line), and choose the brush from the brush panel.

Custom Art Brush You can also create your own brushes in Illustrator. To make your own art brush, simply create the pattern or design for your brush. Then click the "New Brush" icon at the bottom of the brush panel, and choose "New Art Brush" in the pop-up window. In the "Art Brush Options" window that opens, be sure to choose "Tints" from the "Colorization Method" drop-down menu. This will let you change the color of the brush as a stroke color; otherwise, the brush will always be the color that you used to create it.

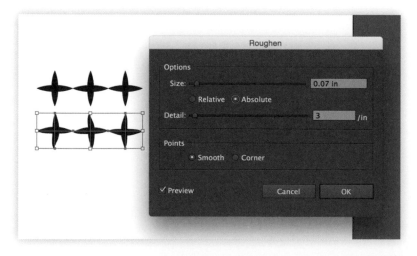

Roughen Effect You can find this effect under Effect > Distort & Transform > Roughen. This is a great tool for making digital illustrations look handmade. The size option determines the intensity of the effect, and the detail bar alters how closely the effect follows the edges. Experiment with these figures to find your preferred balance of detail vs. roughness. The size and complexity of the object will also be a factor; larger objects usually need a higher size value and a lower detail range, whereas the reverse is true for smaller, more detailed shapes.

Shown here you can see the original illustration at top left, with the "roughened" illustration beneath it.

Image Trace Illustrator's image trace feature automatically traces your scanned sketches and illustrations and turns them into vector artwork. You can use this feature by selecting the artwork to trace and navigating to Object > Image Trace > Make. Alternatively, you can open the image trace panel (as shown here) by navigating to the "Window" dropdown menu, and selecting "Image Trace" from the list. "Threshold" determines the overall detail of the trace, "Paths" alters how tightly it traces, "Corners" adds more anchor points, and "Noise" filters how much of the small details the trace picks up.

Shown here you can see the original sketch and the image traced artwork of that sketch beneath it.

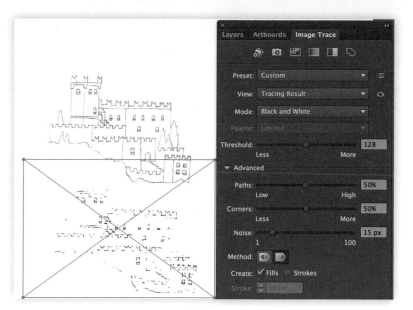

Expanding Objects Expanding an object divides a single object into multiple objects that can be individually tweaked. Select the object to expand, and choose Object > Expand. This feature only works on vector artwork—for example, a sketch you image traced. Here, you can see the original image-traced sketch alongside the same artwork that has been expanded. Note how the selected expanded artwork is made up of many individual dots, or anchor points. With the direct selection tool, which is the solid white arrow on your toolbar, you can select individual parts of the expanded artwork.

Offset Path The offset path effect replicates an object and sets it off from the selected object by a specified distance. This is an especially helpful tool for creating concentric shapes or multiple replications of an object with equal distance between each. Select the object, and navigate to Object > Path > Offset Path.

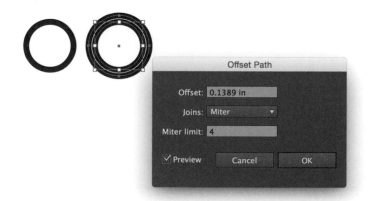

LAKE GARDA

Lake Garda is the largest lake in Italy. What fascinated me most about my trip here was the ferries that skirted around the towns and villages on the water's edge. I wanted this map to be about them—these little towns and the routes the boats take, which link all these places together.

I roughly trace around the outline of the area, and number the spots where I want to illustrate something interesting. The numbers refer to a list of potential points of interest (POI's) I thought would make good illustrations. There were many things I wanted to cram into the map, but I had to remain selective and choose what works compositionally. Next I add other important details, leaving space for traditional map elements like a compass and a title. To finish my rough sketch, I add topographical markers to flesh out empty areas of the map. I try to stick to the real topographical features of the landscape whenever possible.

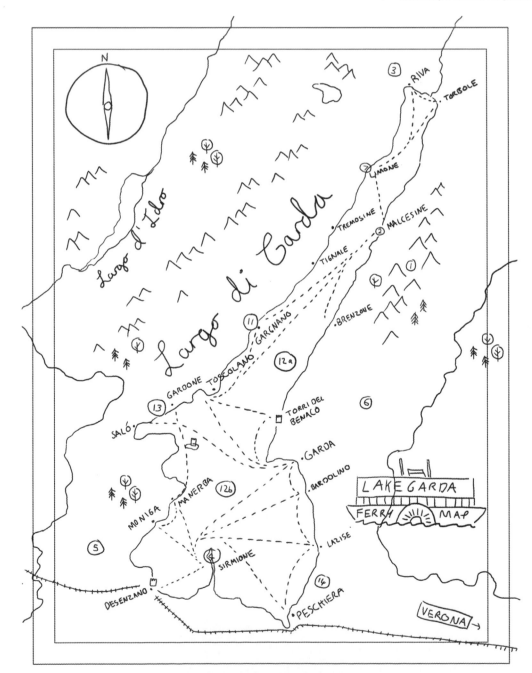

TIP

I sometimes draw the outline of the country or place freehand, but I usually trace a digital screenshot for two reasons: (1) it saves a lot of time, and (2) it ensures accuracy.

(Opposite) Next I sketch the POI's. I do a lot of image research at this stage and look for pictures I like that show the subject at the right type of perspective. I draw from these, often distorting the angle and simplifying the subject as much as I can without losing too much detail. When working digitally, I scan all the drawings into the computer and clean them up a bit.

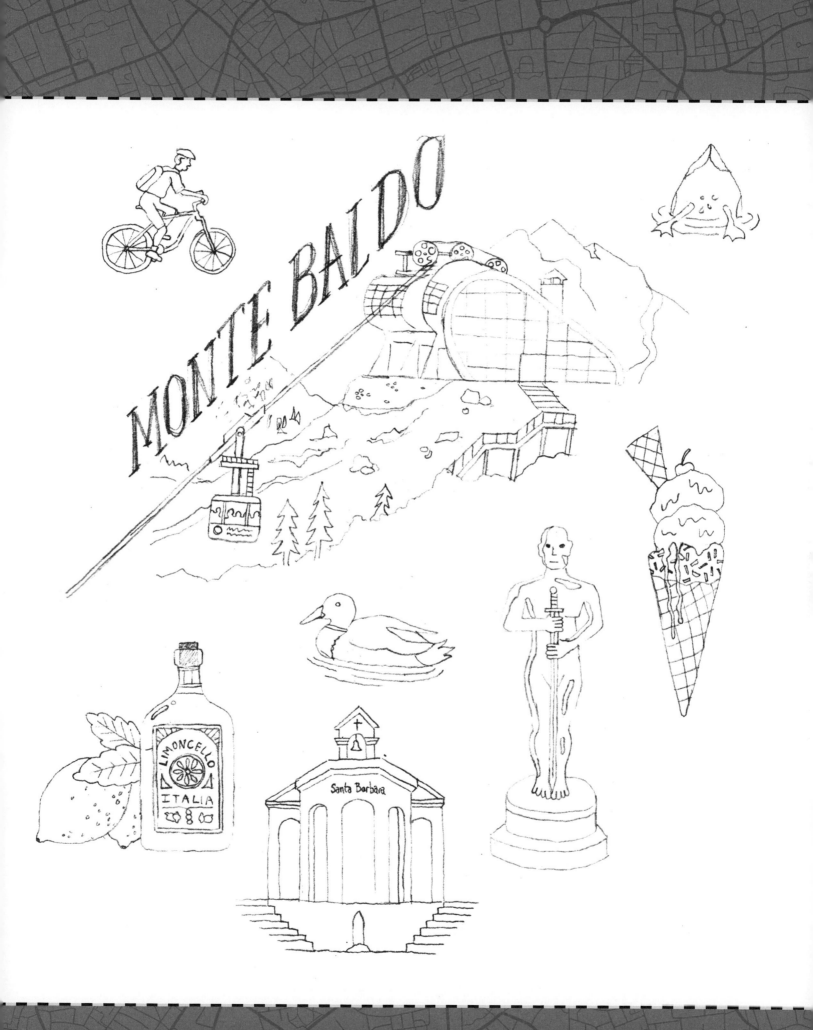

MONTE BAIDO

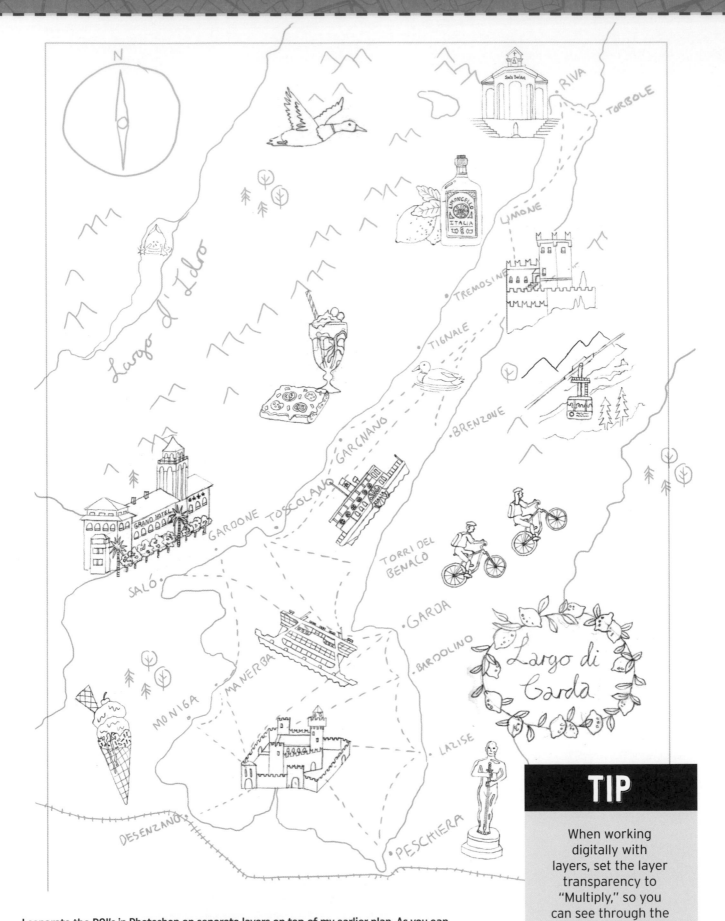

I separate the POI's in Photoshop on separate layers on top of my earlier plan. As you can see, I rotated, flipped, or erased sections of my drawings to make them fit.

TIP

When working digitally with layers, set the layer transparency to "Multiply," so you can see through the white of the paper.

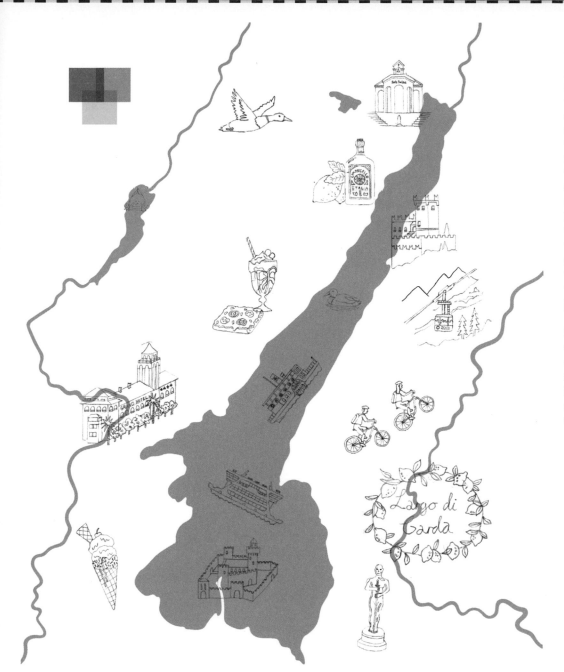

I prefer to add color in Illustrator, rather than Photoshop. Illustrator uses vectors, so you can adjust the size many times and to any scale without losing quality. You can also create lots of shapes in the same layer so the file sizes are much smaller and faster. I export the Photoshop layers to Illustrator separately, as JPEGs. First I work on the background, using the map screenshot. I use the pen tool to trace around the lake and the brush tool, with the pressure sensitivity turned on, to create thick and thin bends in the river. In the top left, you can see my color palette.

Next I bring in the Photoshop layer with my POI's and place the image on its own layer, set to "Multiply," above the rest of the artwork, so I can flick the layer's visibility on and off to see how the work is taking shape.

I create a new layer above the green one for white objects. I don't want to subtract anything at this stage, to ensure the freedom to move and scale objects around freely. Then I use the pen tool to trace around my first POI, one of the ferries. I repeat this process, creating a separate layer for the different colors, altering the opacity of the shapes to "Multiply" to replicate an overprint effect similar to screen printing. I love the look of that traditional technique. I also deliberately overlap and offset some of the layers slightly to give the artwork a slightly mis-registered appearance.

The pen tool allows you to outline and fill shapes very quickly, but it creates very clean and precise edges. My style aims to emulate a handmade technique, so I like to add a "Roughen" filter to the objects. Experiment with the different settings to find your preferred balance of detail vs. roughness. See page 44 for more tips on using this effect.

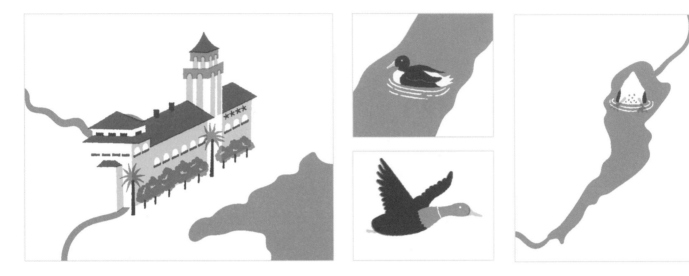

I repeat this process for the Grand Hotel, another four POI's, and two ducks. On looser shapes, such as the chocolate sauce in the milkshake glass, I like to use the pencil tool instead of the pen tool, because it's faster. Imprecise shapes require a lot more anchor points than a regular shape. With the pencil tool you can draw the whole shape in almost one motion. There are many settings you can adjust to alter how closely the shape you create matches the original line. Again, it's a balance of smoothness over accuracy.

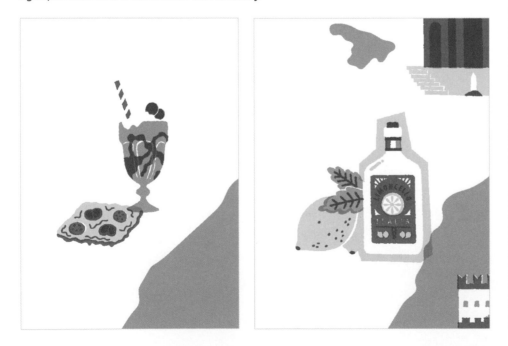

(Opposite) I decide to change the background to yellow and reverse the lakes and rivers to white. I also make some adjustments to all the POI's to account for the new background. As mentioned before, I don't subtract anything at this stage, so I cheat a little bit with additional layers that I will remove later when I bring it back into Photoshop.

For POI's that are yellow, such as the lemons or the Oscar statue, I create white "cutout" shapes around the illustration to keep the object from merging into the background.

Finally, I bring in the topography layer from my Photoshop sketch to begin adding the trees, mountains, railways, and a compass. These little elements fill out any empty space and go a long way in making the illustration start to look like a map.

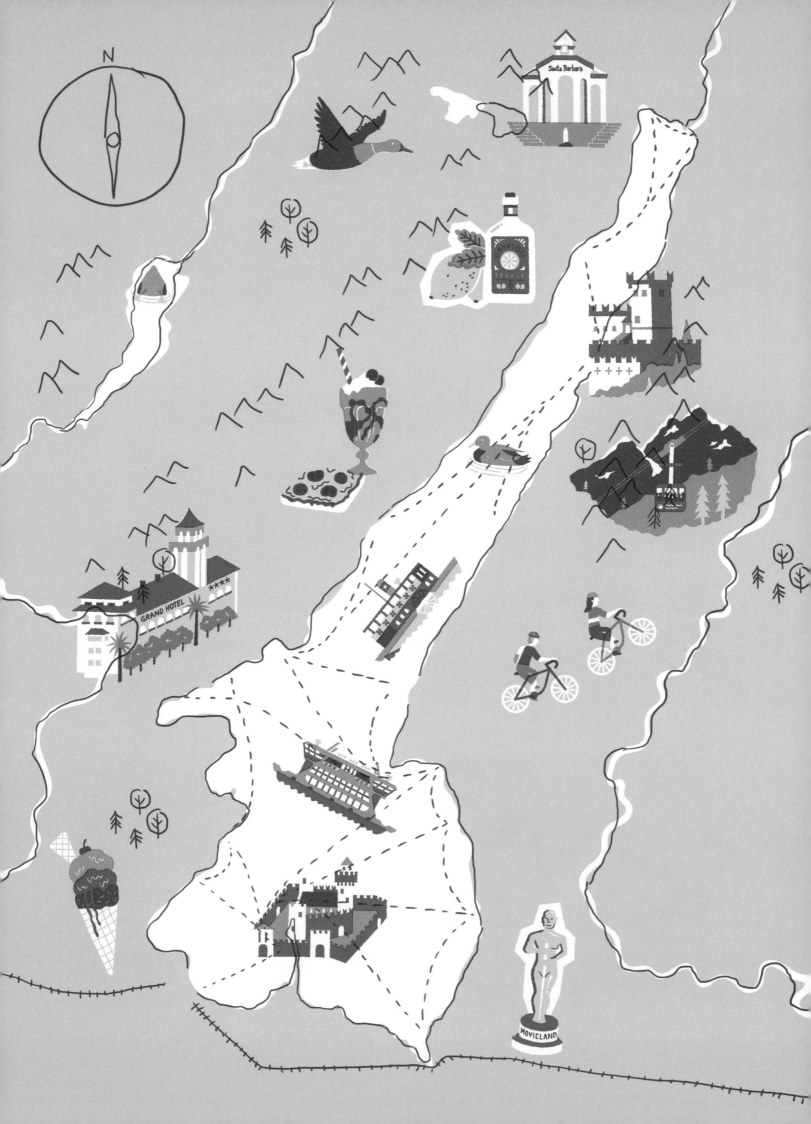

I start with the railway. To make the track, I use a simple Illustrator trick that saves a lot of time and effort.

First I make a small, straight black section of track using the pen tool. Then I create a new "pattern brush" using the shape I made. There are lots of settings you can explore, but I chose the "Approximate Path" setting, which retains the original artwork without distorting the shape. Setting the spacing to zero prevents gaps, and I set the colorization method to "Tints." With the "Tints" box checked and the pattern black, you can alter the brush color just by changing the stroke color. See page 44 for more tips on creating your own custom brush.

Next I simply draw a colored line with the pen tool (above left) and change the "Stroke Style" to the pattern brush I made (bottom left). Voilà!

(Opposite) Next I add place names, trees, and mountains. You can individually hand letter each bit of type, but to save time I digitized a few of my own custom typefaces to use in my maps. There are many different font-making programs, ranging in price. I use a website called www.calligraphr.com, which isn't perfect, but it's free and does a great job.

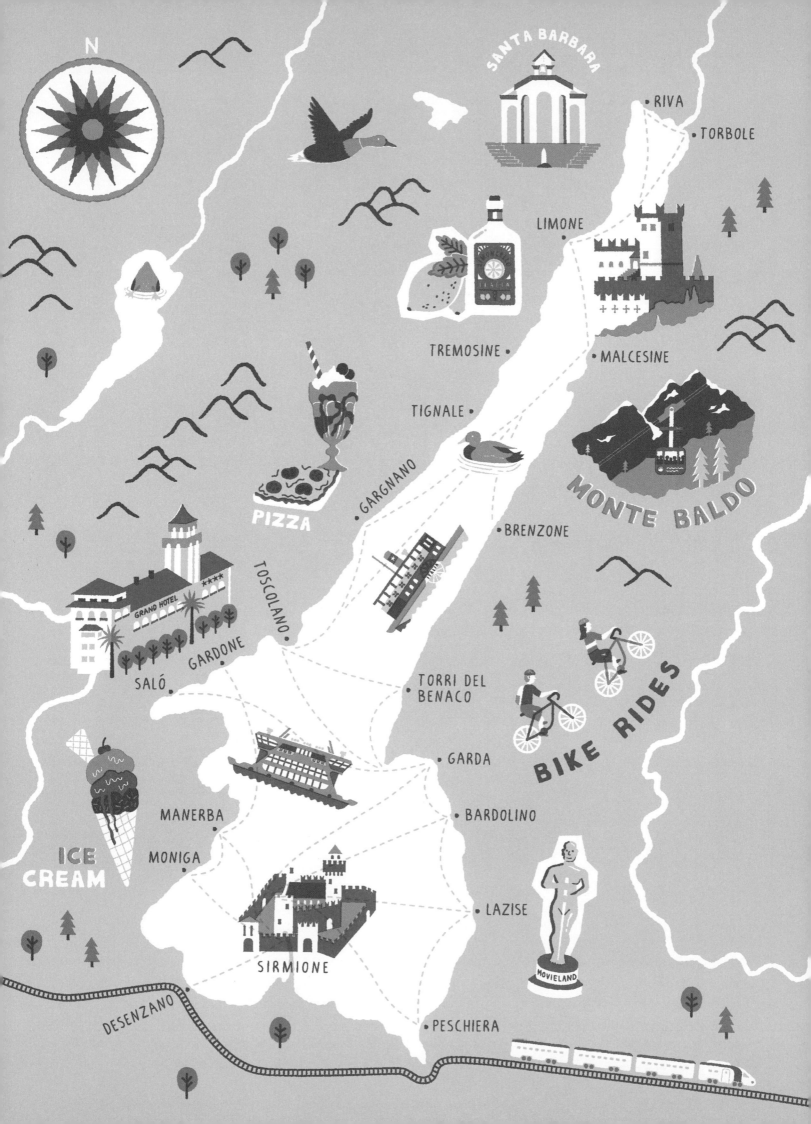

N

SANTA BARBARA

RIVA

TORBOLE

LIMONE

TREMOSINE

MALCESINE

TIGNALE

MONTE BALDO

PIZZA

GARGNANO

BRENZONE

TOSCOLANO

GRAND HOTEL

GARDONE

SALÓ

TORRI DEL BENACO

BIKE RIDES

GARDA

ICE CREAM

MANERBA

BARDOLINO

MONIGA

LAZISE

MOVIELAND

SIRMIONE

DESENZANO

PESCHIERA

Once finished in Illustrator, I start moving things back to Photoshop, moving the objects grouped by color. I start with the solid yellow background. I bring in my "cheat" white layer and subtract it from the yellow. Then I bring in the greens, setting the layer style to "Multiply" again to get that nice overprinted effect.

(Opposite) Next I bring over the peach layer. Finally, I bring in the last layer—the brown color that results from combining the green and peach. I set this as a solid layer (no multiply). I mainly do this for line work or text that I want to be clear and legible, without any misprinted edges. Now all the artwork is separated over only four fixed layers. I like this stage, when everything gets subtracted and condensed. It always amazes me how much you can achieve with so few colors!

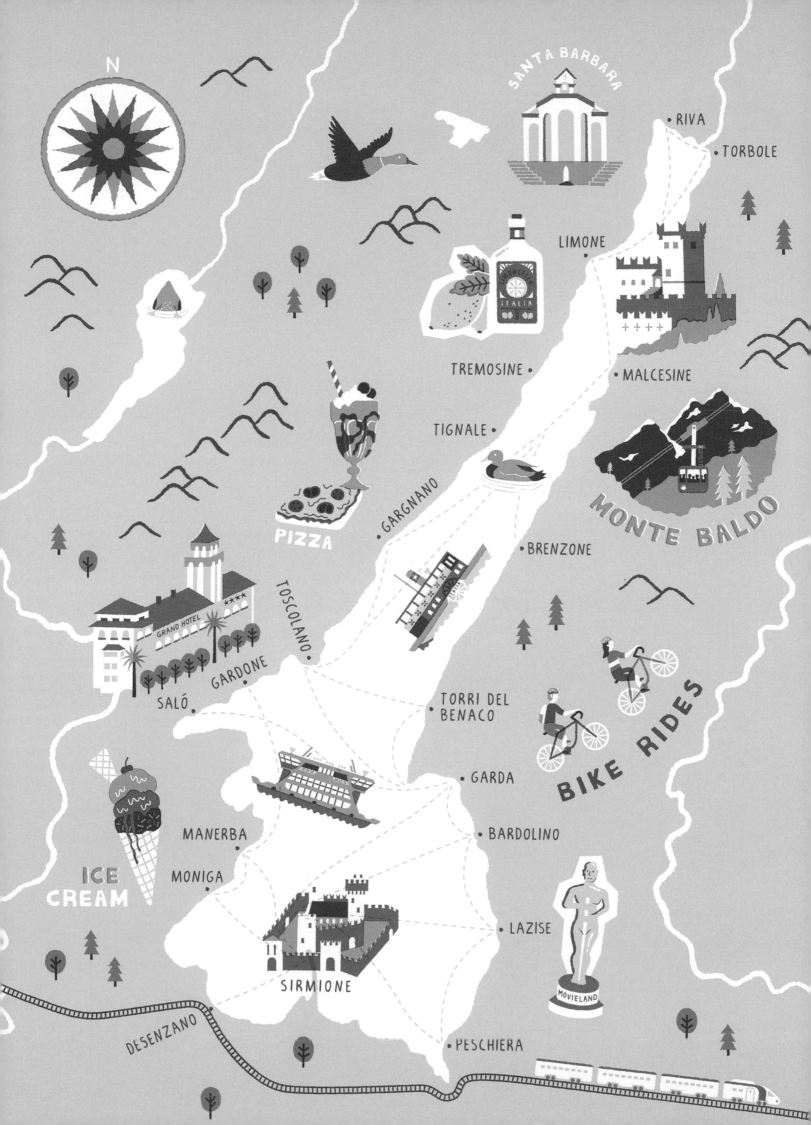

I begin texturizing the artwork with some of my own custom brushes. I created these using a mixture of paint splashes, some of which I scanned in and some that I downloaded from the Internet. I needed to give the splashes a screen-printed aesthetic. To do so, I used Photoshop's "Color Halftone" filter, setting all the channels to zero with a max radius of about eight pixels. This creates a pixelated effect that makes it look like the ink splash passed through a silk screen. Shown above is an example of this effect.

I then crudely select the shape using the lasso tool, and define the area as a new brush preset. To make sure that the dots aren't too close together, I make the paint splash a mid-gray. The lighter the color, the less densely the halftone pixels will be packed. Next I use these new brushes on each of my four layers, sometimes as erasers creating under-inked dry patches, and the rest of time as brushes creating artificial splashes of misprinted ink. In this close-up you can see the subtle texture of the map.

TIP

There are many online sources for free grungy textures you can download. A couple of my favorites are www.blog.spoongraphics.co.uk and www.lostandtaken.com.

(Opposite) To finish, I add some intricate freehand line work and hand lettering, which is more difficult to produce in Illustrator due to its tendency to smooth out the lines. I use a great Photoshop brush set to add stippled, shaded, and textured lines. With these final touches, my map of Lake Garda and its ferries is complete!

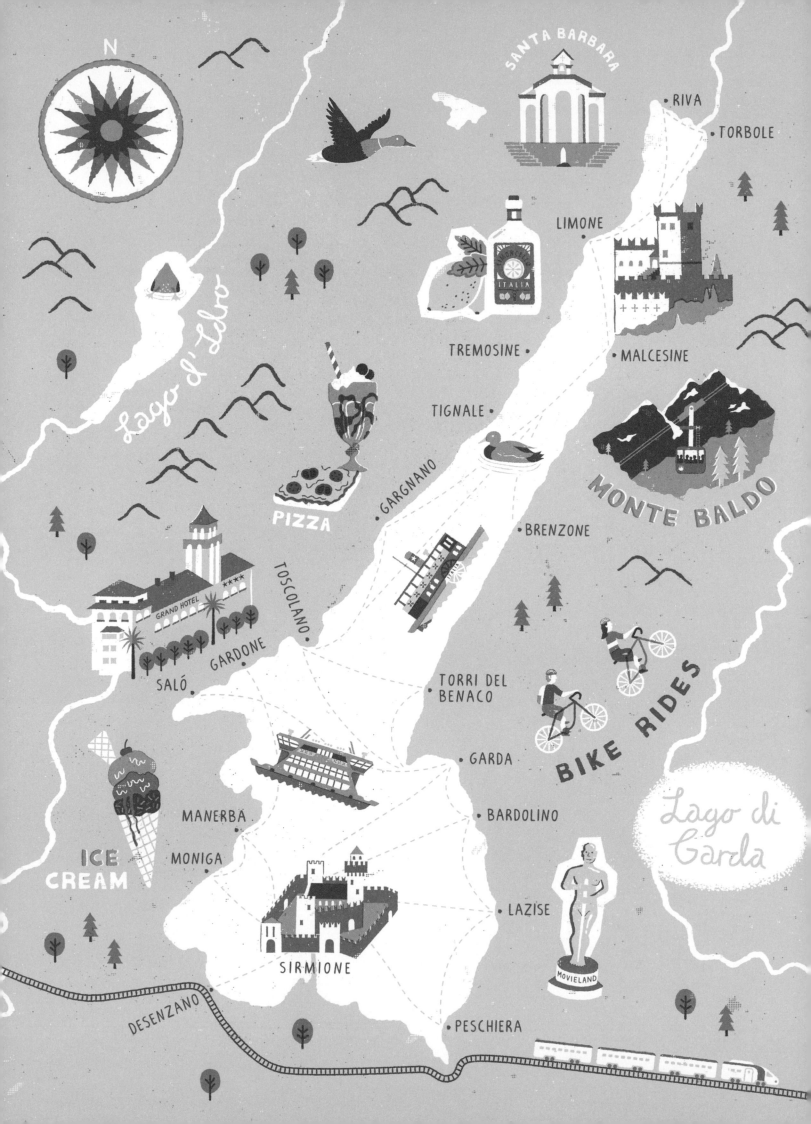

I drew inspiration for this map from a 300-mile bike ride down the west coast of France, which I completed with my best friend.

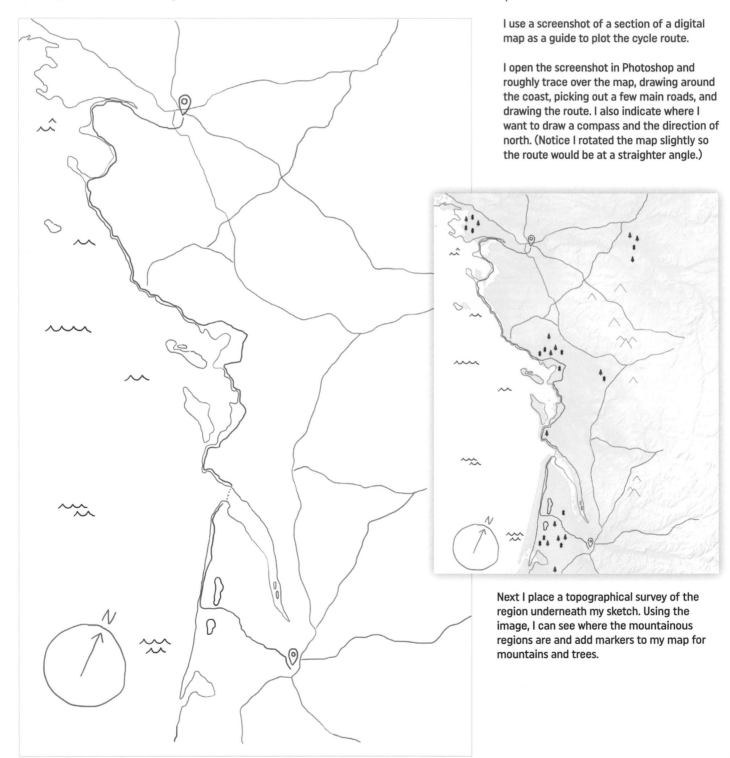

I use a screenshot of a section of a digital map as a guide to plot the cycle route.

I open the screenshot in Photoshop and roughly trace over the map, drawing around the coast, picking out a few main roads, and drawing the route. I also indicate where I want to draw a compass and the direction of north. (Notice I rotated the map slightly so the route would be at a straighter angle.)

Next I place a topographical survey of the region underneath my sketch. Using the image, I can see where the mountainous regions are and add markers to my map for mountains and trees.

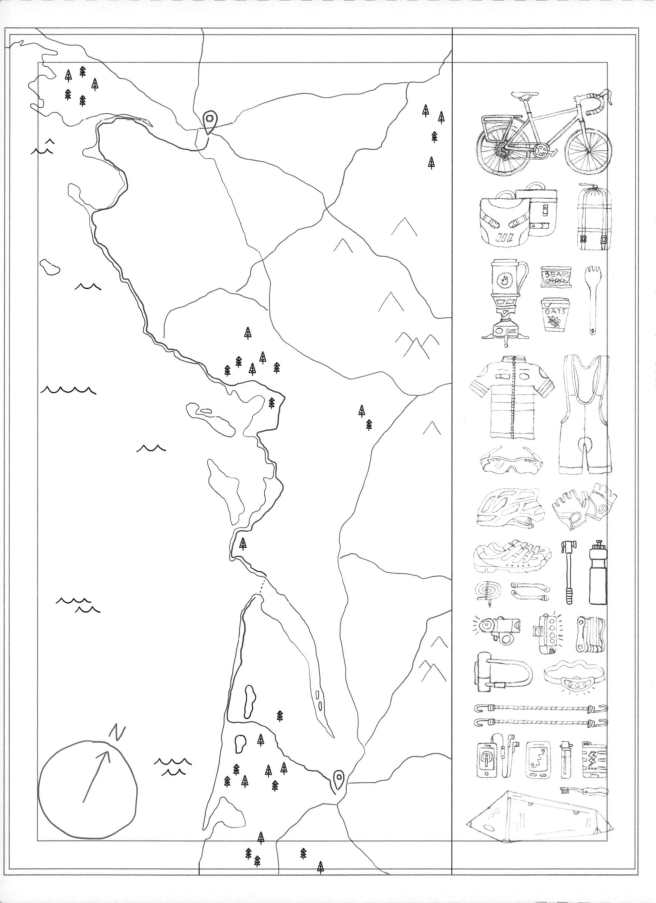

On the side of my sketch, I include an illustrated itinerary of what I took with me. I thought it would be fun to draw some of the stuff I lugged around on the back of my bike for 300 miles. I sketched almost everything in my sketchbook, scanned them in to my computer, and arranged the drawings. It took some maneuvering, and the scales of the items aren't consistent, but that's okay. Don't be afraid to try something new in your mapmaking—you may surprise yourself!

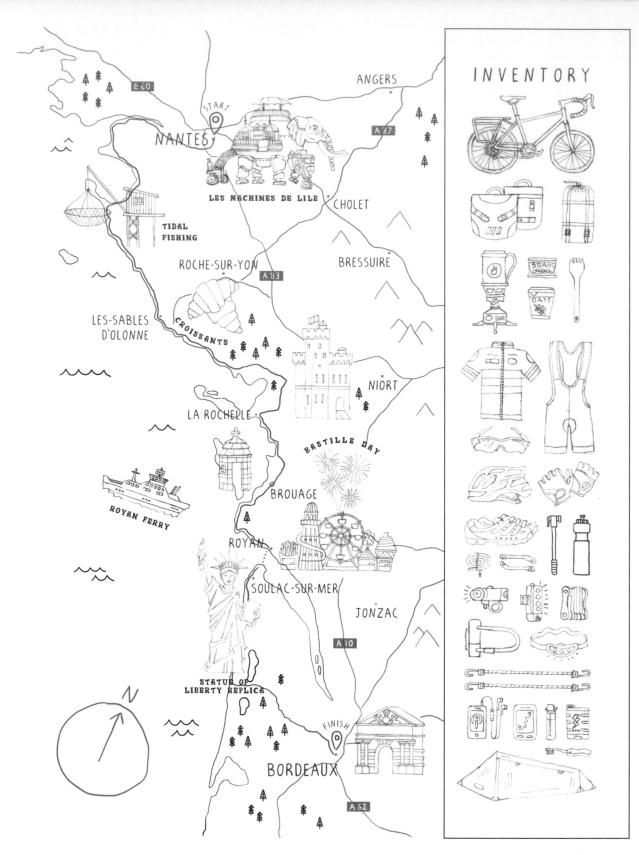

Next I draw the points of interest (POI's) in my sketchbook, scan them into the computer for a bit of cleanup, and copy them into my Photoshop document with the "Multiply" opacity setting on. I add the town names and some POI labels using a combination of two of my own fonts, which I created using an online font maker (www.calligraphr.com). One of the fonts was inspired by fairground signage, which was fitting because we went during Bastille Day and the Euro Cup Final (which France was in), so the whole country seemed to be having a weeklong party.

I switch to Illustrator and bring in a JPEG file of the Photoshop layer containing all the background elements, which I quickly trace over with the pencil tool, using the "Roughen" filter to distort the shapes slightly.

Next I create the mountains. First I create a triangle and fill it with a gradient. I set the angle to 90 degrees so the black descends from the top of the mountain. Altering the "Location" changes how strong and far either end of the gradient extends. I moved the "Location" closer to the white end of the scale. Then I added a grain effect. Using the filter, with the grain type set to stippled, I altered the intensity and contrast settings until I was happy with the result. Then I expanded the appearance of the shape.

Now I can use the "Image Trace" tool to re-vectorize the object. There are settings you can adjust in the trace toolbar. I wanted to capture the grittiness of the effect, without capturing every little speck. Once you have found the right combination of settings you can save the preset and use it instantly each time you want to trace something in a similar way. I expanded the object once more, and now I can alter the color and size like any other vector shape (see below).

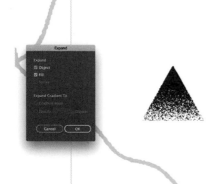

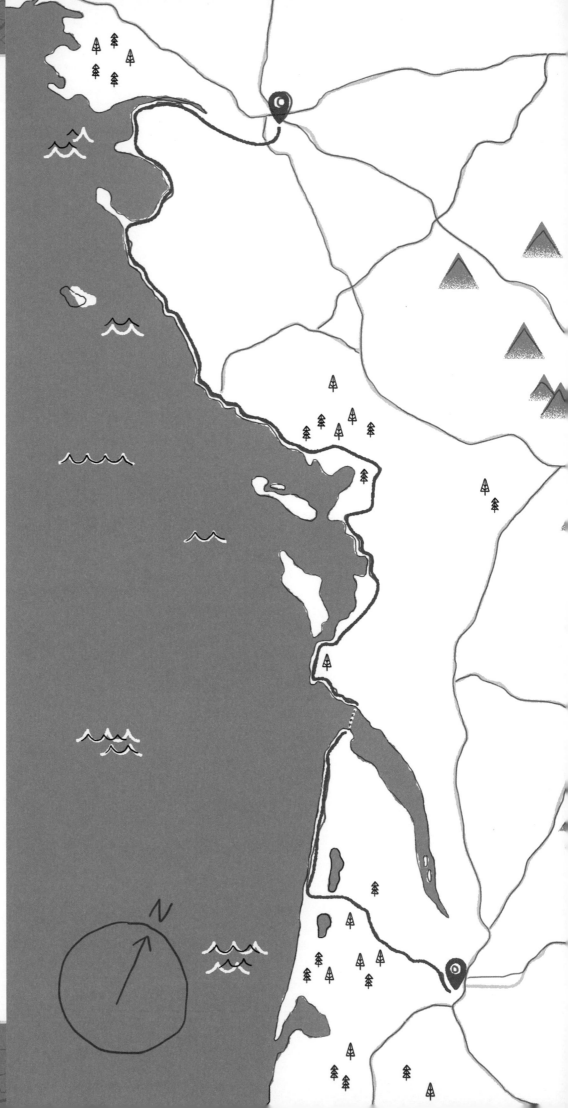

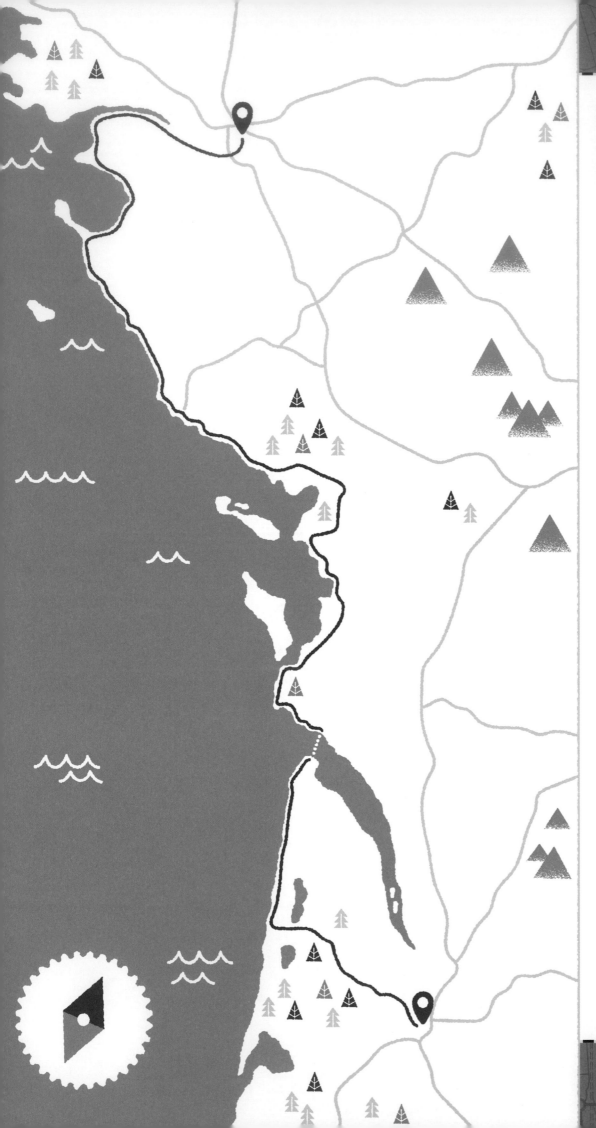

Next I add trees and a compass to the map. I created the cog-shaped background of the compass using the star shape tool. For a detailed tutorial on how to do this visit www.quartoknows.com/page/mapillustrationbonuses and download the bonus material.

(Opposite) Next I bring in the JPEG containing my inventory and draw around all the items using the pen tool. I had to think creatively with some of the objects—restricting yourself to only a few colors presents challenges, which is why I often draw things as simply and clearly as possible. Since I wasn't trying to replicate a screen-printed aesthetic, I kept all the items on the same layer, which made things much simpler.

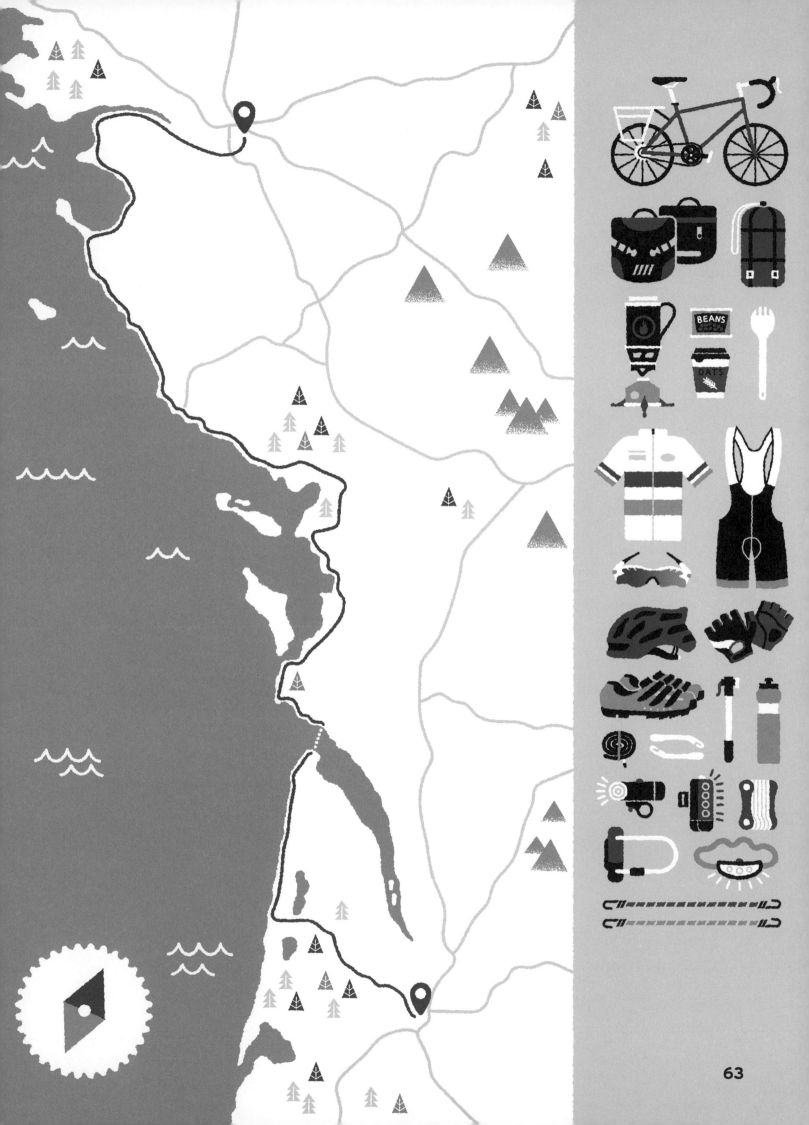

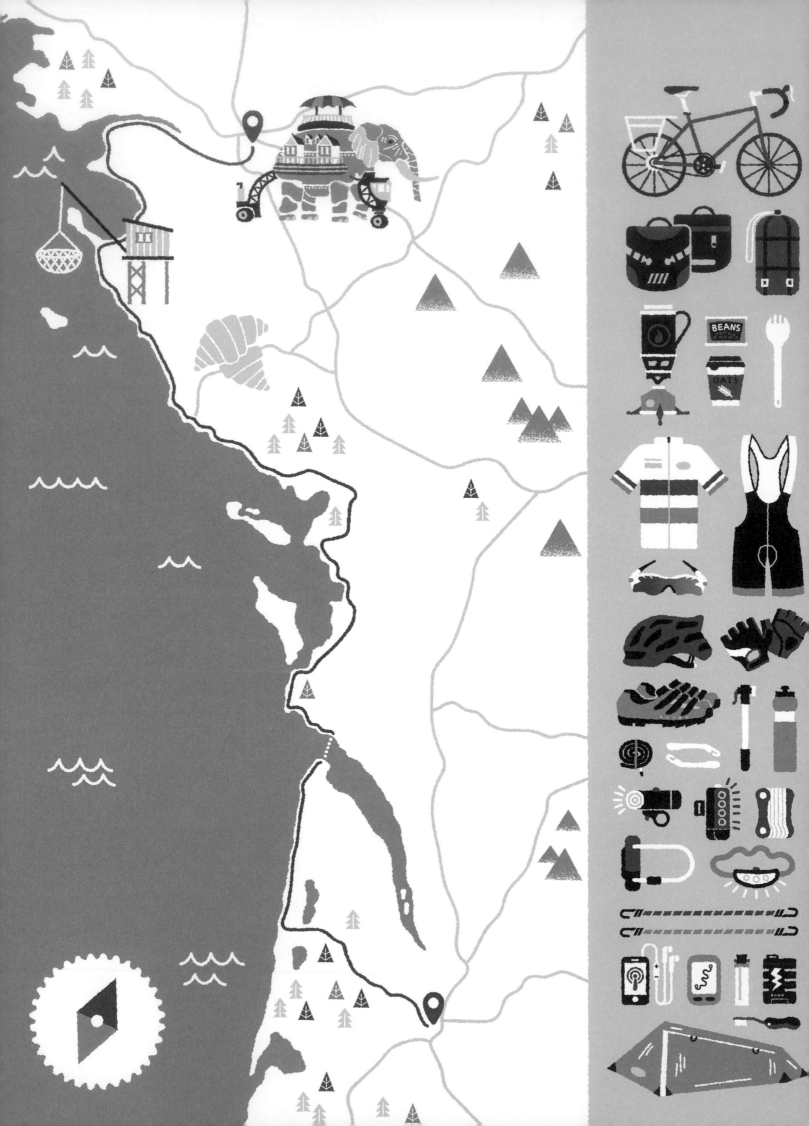

After finishing the inventory items, I begin drawing the POI's, starting with the mechanical elephant I saw in Nantes. This creature is made up of multiple panels, so I thought the simplest way to represent that was to break it into parts with small gaps between each of the sections. Rather than trying to draw the same exact curves on either side of the gap, I cheated and used Illustrator's "Offset Path" setting. See page 45 for more tips on using this tool.

First I draw two shapes overlapping one another. I select the shape with the curve I want to use and apply the "Offset Path" setting with only a small value entered. (The larger the value, the bigger the resulting offset.) I subtract the resulting shape from the adjacent panel, creating a curve that matches the adjacent one. I repeated this process until I make the entire body.

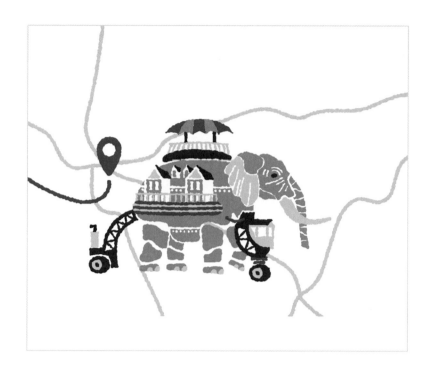

To make the fairground, I use a few techniques that I haven't mentioned yet. (For a full tutorial on creating the fairground, download the bonus material at www.quartoknows.com/page/mapillustrationbonuses.) For the Ferris wheel, I use the "Rotate" tool to quickly duplicate elements. If you double-click the "Rotate" tool, a new window opens where you can specify the rotation amount. Pressing "Copy" rotates and copies the original shape. By pressing CTRL + D afterward, you can repeat the action as many times as you like. Holding the alt (or option) button while using the "Rotate" tool allows you to move the rotation point to wherever your cursor is pointed.

To make the wavy shape on the food and balloon stands, I make a straight line and then apply the "Zig Zag" effect, found under the "Distort & Transform" menu (Effect > Distort & Transform > Zig Zag). The size bar alters the strength of the effect, and the ridges setting determines the number of ripples. I ticked the "Smooth" box to create rounded waves. I expand the effect and use the pen tool to complete the shape; then all I had to do was turn off the stroke color and select the fill color.

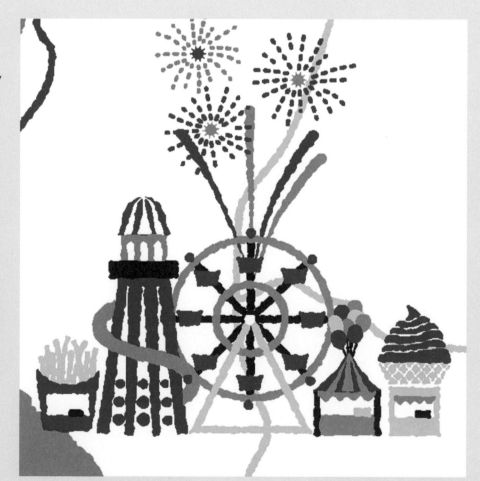

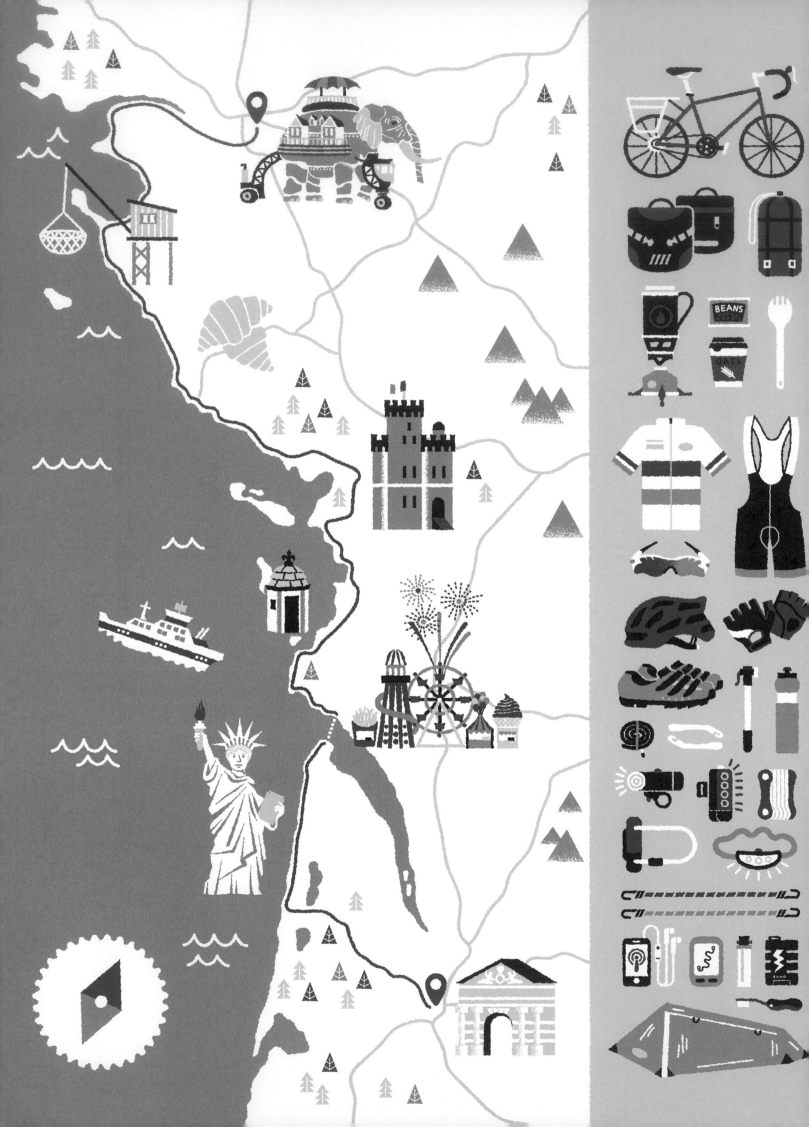

(Opposite) I continue making the rest of the POI's one by one. I use the grain effect a few times to add shadow.

To give the illustration a retro, slightly grainy filter, I explore a few different styles and settle on adding a "Mezzotint" effect. I flatten the Illustrator artwork and convert the layer into a smart object so I can fine-tune the filter. I use the mezzotint effect on the "Coarse Dots" setting to exaggerate the style. By clicking the adjustment icon on the right-hand side of the smart filter, I change the blending mode to "Linear Light" on a low-opacity setting to reduce the strength of the effect.

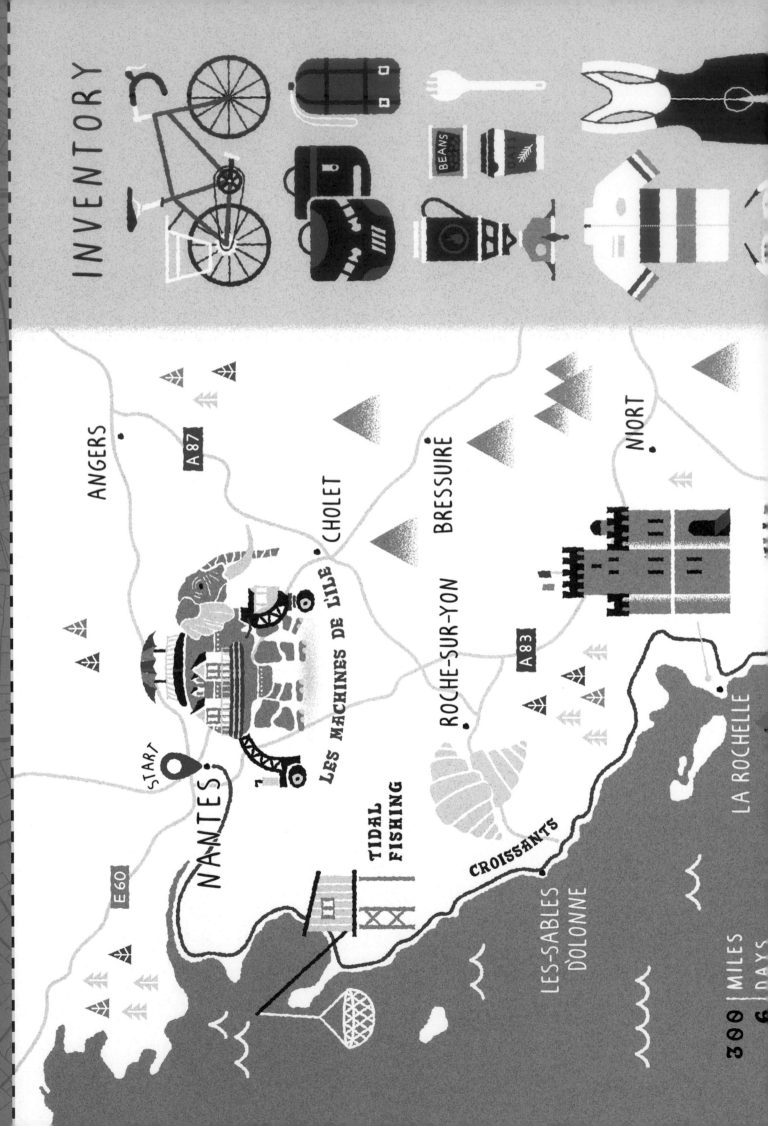

INVENTORY

BEANS
OATS

ANGERS

A87

CHOLET

BRESSUIRÉ

NIORT

START

NANTES

LES MACHINES DE L'ÎLE

ROCHE-SUR-YON

A83

E60

TIDAL FISHING

CROISSANTS

LA ROCHELLE

LES-SABLES DOLONNE

300 MILES
6 DAYS

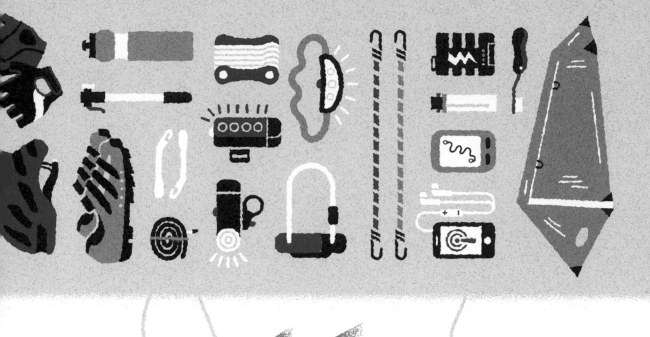

JONZAC

A10

BROUAGE

SOULAC-SUR-MER

FINISH

BORDEAUX

ROYAN

STATUE OF LIBERTY REPLICA

I add the text and a shadow underneath the mechanical elephant using the grain effect. Instead of using a liner gradient, I use a radial one, with the darkest point being the center of the circle. After applying the mezzotint effect, I adjust the saturation levels slightly and the map is complete!

This map is based on a recent adventure to Indonesia. We traveled around the east of Bali and across to the Gili Islands for a few weeks.

For reference, I took a screenshot of the area I wanted to draw. I took some creative liberties by moving and adjusting the size of some of the islands to fit everything I wanted and leave room for a compass in the bottom right corner. Illustrated maps don't always have to be completely accurate—the map is more like a journal, rather than something to navigate by.

I trace the islands in Photoshop and add towns, a rough compass, and markers for the points of interest (POI's). I also draw a box around the Gili Islands to indicate that they are added to the map from an area just outside its boundary. This is a common trick in cartography—for instance, take a look at a map of the United Kingdom, which commonly features the Shetland Islands in this way.

AMED

⑪

①

⑤

③

⑦

②

UBUD

PADANG BAI

⑩

DENPASAR
☆

⑥

SANUR

④

KUTA

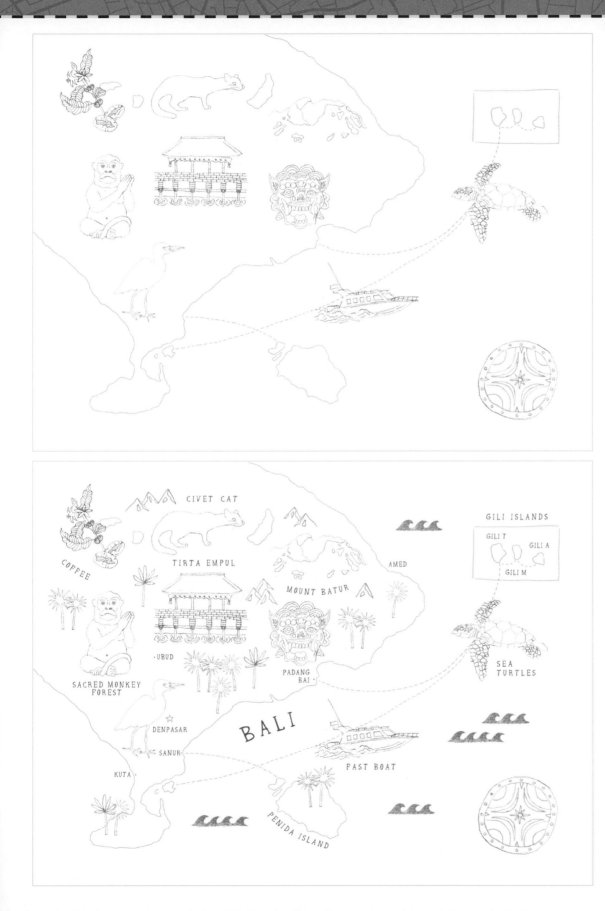

Next I sketch the POI's in my sketchbook and scan them. After a bit of cleaning up in Photoshop, I bring each image into the document, setting the opacity to "Multiply," and arranging them on the map. Bali has a rich cultural heritage, and I wanted to reflect that in the compass design and the traditional Balinese mask. I also add the boat route that took us to the Gili Islands and to Kuta.

I add trees, mountains, and waves. I usually draw these items quite small and scatter lots of them around the map, but this time I made these elements larger. The tropical terrain is a big feature of the island, and I want to emphasize that. I also add text for the POI's and towns.

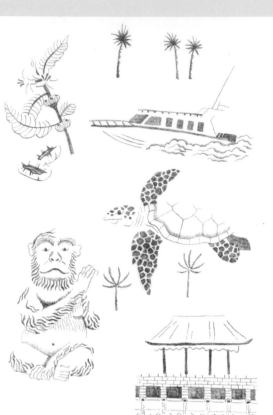

Bali is rooted in traditional art and beliefs, so I want to create a hand-drawn aesthetic for this map. To do so, I use a lightbox and layout paper to draw over my original sketch. However, rather than tracing every single line, I picked out areas of shadow with rough pencil strokes and some edges to add definition.

Then I scan the layout paper and clean it up in Photoshop. I open the clean scan in Illustrator and use the "Image Trace" tool to vectorize the lines, with a high threshold and path setting to capture most of the detail. Some lines are broken and slightly distorted, which adds to the roughened, handmade appearance I want.

I bring the first of my sketch layers into Illustrator and use the pen tool to draw around the islands and create the small box around the Gili Islands.

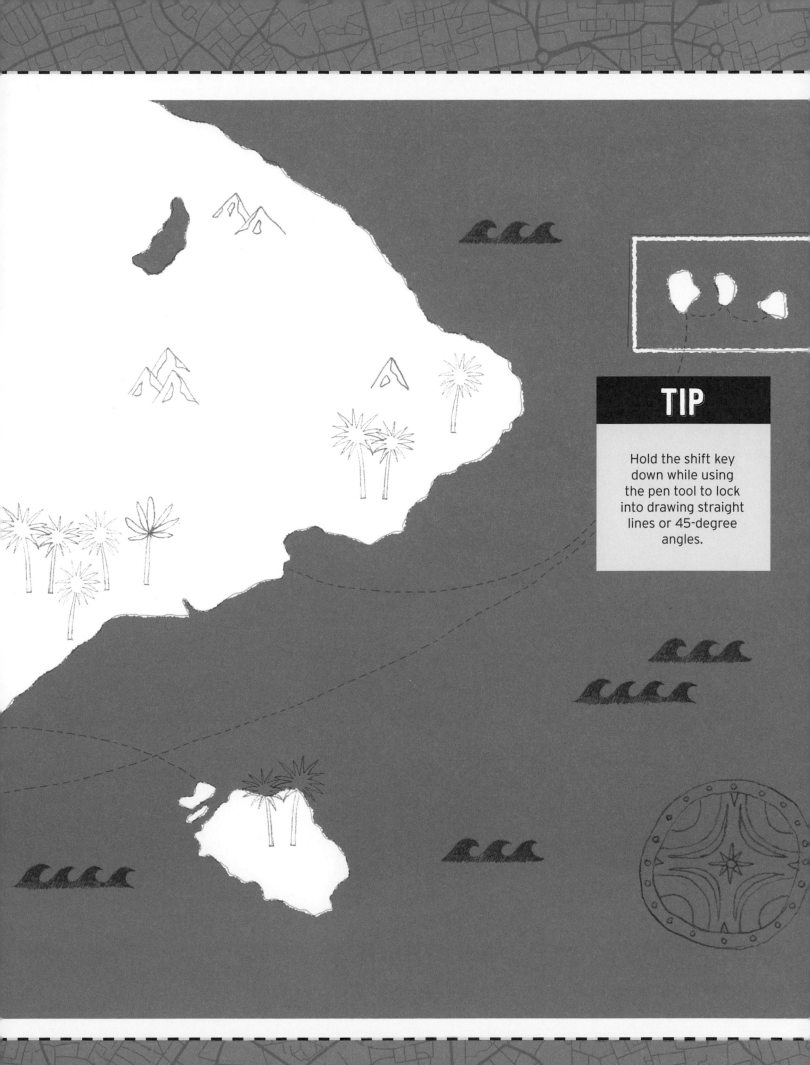

TIP

Hold the shift key down while using the pen tool to lock into drawing straight lines or 45-degree angles.

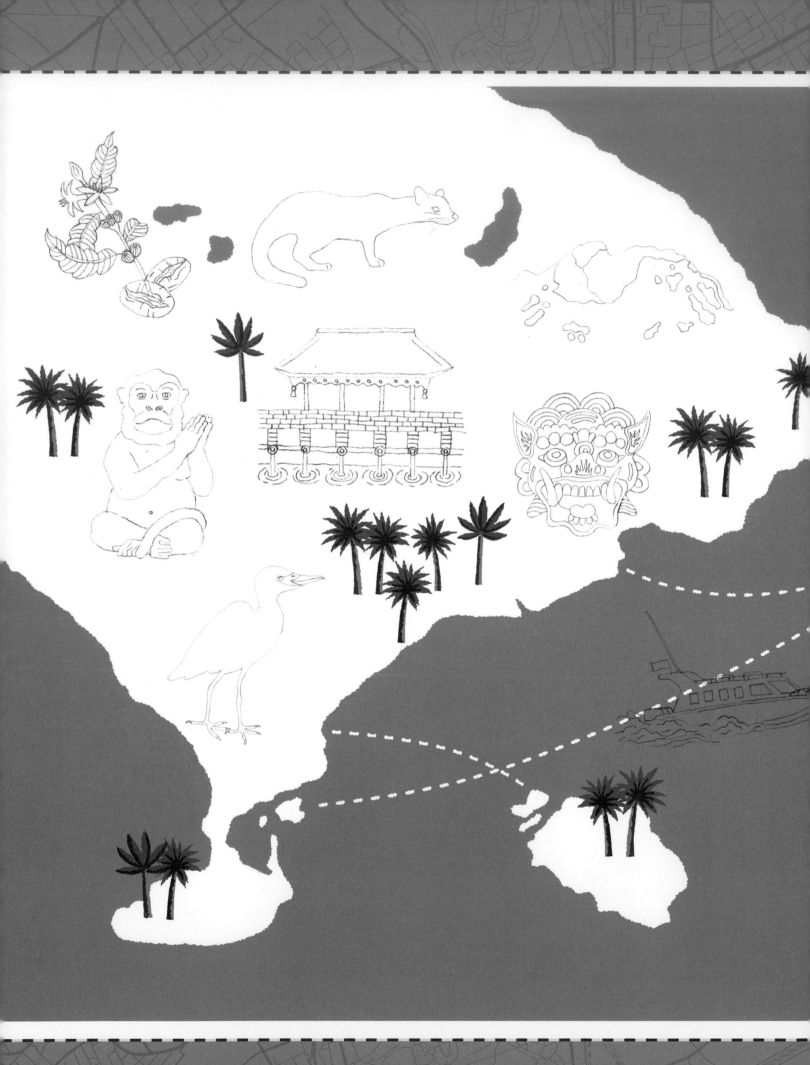

Next I add trees to the map by drawing around the outlines with the pen tool. I apply the "Roughen" filter to slightly distress the edges. Then I paste the image-traced lines from the previous step into the document. I alter the color and line the new shapes up with the trees. I set the opacity to "Multiply" to make the shapes darker and create an overprint effect.

I bring in the image containing my POI's and line it up with the map, setting the opacity to "Multiply" on a locked layer above the artwork so I can work underneath the line sketch without accidentally moving it.

Next I start the process of adding color to the POI's, beginning with the sea turtle. I start this process very similar to how I made the trees. I block in the colors with the pen tool, using the sketch as a guide. Then I place the image-traced lines on top of the shapes and set its opacity to "Multiply." The lines were too heavily broken up on the turtle's shell, so I use the brush tool with the pressure sensitivity turned on to fill in the missing lines. Then I expand the lines, group them together (Object > Group), and set the opacity to "Multiply." I apply the "Roughen" filter to the colored shapes and create a white area for the eye.

The most challenging part was creating the pattern on the shell. Illustrator has a great "Zig Zag" tool, which I used on a series of lines that mirrored the contours of the shell.

Visit www.quartoknows.com/page/
mapillustrationbonuses and download the bonus material to find a step-by-step photo tutorial for creating the trees in Illustrator.

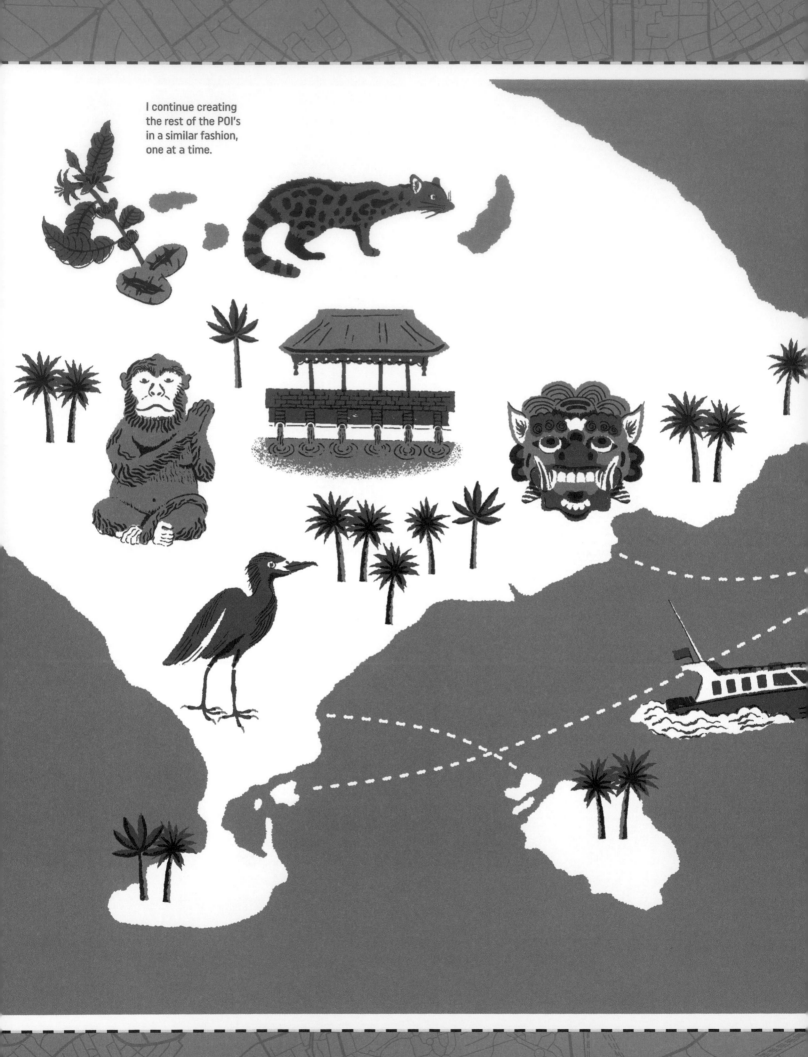

I continue creating
the rest of the POI's
in a similar fashion,
one at a time.

To fade the water in the temple pool into the background, I use a stipple effect. To get this look, I create a circle with a radial gradient, with the aspect ratio set to 30 degrees to create a flatter curve. Then I use Illustrator's "Grain" tool to create the stippled look. I use the "Image Trace" tool to vectorize the new shape, expand the shape, and convert it into a compound path. Using the "Pathfinder" tool's "minus back" option, I remove a square shape that follows the base of the structure. To finish, I move the stippled shape to the back of the artwork. For a full step-by-step demonstration of this process, download the bonus material at www.quartoknows.com/page/mapillustrationbonuses.

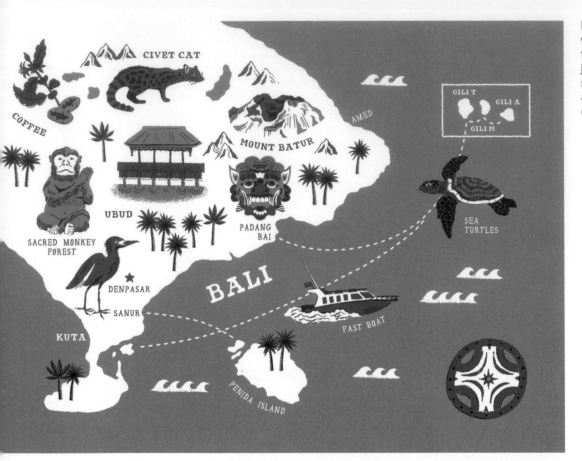

I bring in the mountains and waves, which I had image-traced from my sketches—just like I did for the POI shadows and outlines. Then I add all the text using my own custom fonts.

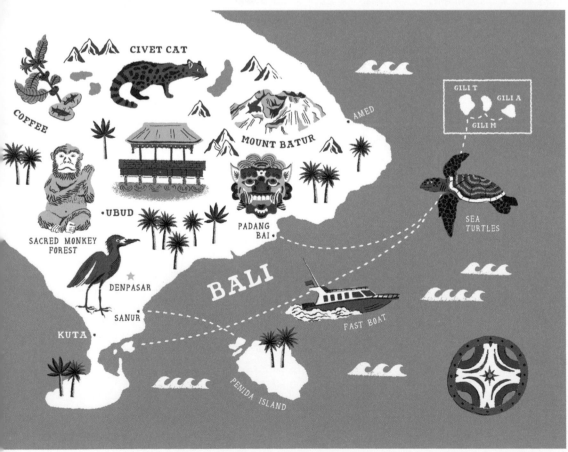

I decide to change the brown background to turquoise and add a light gray to the color palette. You can quickly change colors in Illustrator by going to the "Select" tab, navigating to "Same," and choosing "Fill Color."

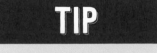

TIP

To choose colors that work well together, convert your palette to grayscale to ensure there is a good contrast between the different swatches.

Next I bring the Illustrator objects into Photoshop to add textures. I separate the objects into five groups/layers: (1) the sea, (2) the land, (3) the illustrations, (4) the image-traced lines (set to "Multiply"), and (5) the text. This will allow me to create different textures on individual layers.

You can create your own inky texture by using printing ink, a roller, and your scanner. I use an inked texture from a pack that I purchased; the texture has a transparent background, so I simply paste the image into my Photoshop document (above) and use "Color Overlay" in the layer style to change the texture's color to a slightly lighter green than the background (left).

I do the same for the land layer. This time, I click on the land layer in the side tab while holding the control key to select the entire shape. I create a layer mask using the selection to restrict the texture to the land, and I adjust the opacity for a subtler look. I also use the eraser tool and a rough brush to reduce the strength of the effect around the POI's.

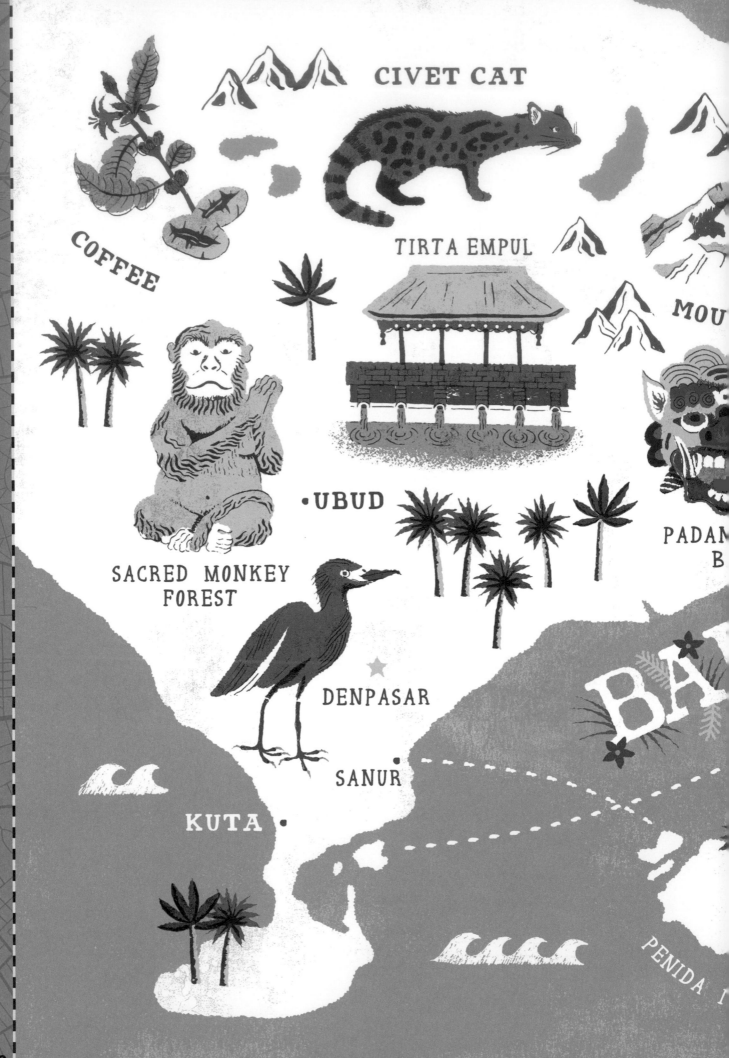

CIVET CAT

COFFEE

TIRTA EMPUL

MOU

SACRED MONKEY
FOREST

•UBUD

PADAM
B

DENPASAR

BA

SANUR

KUTA •

PENIDA

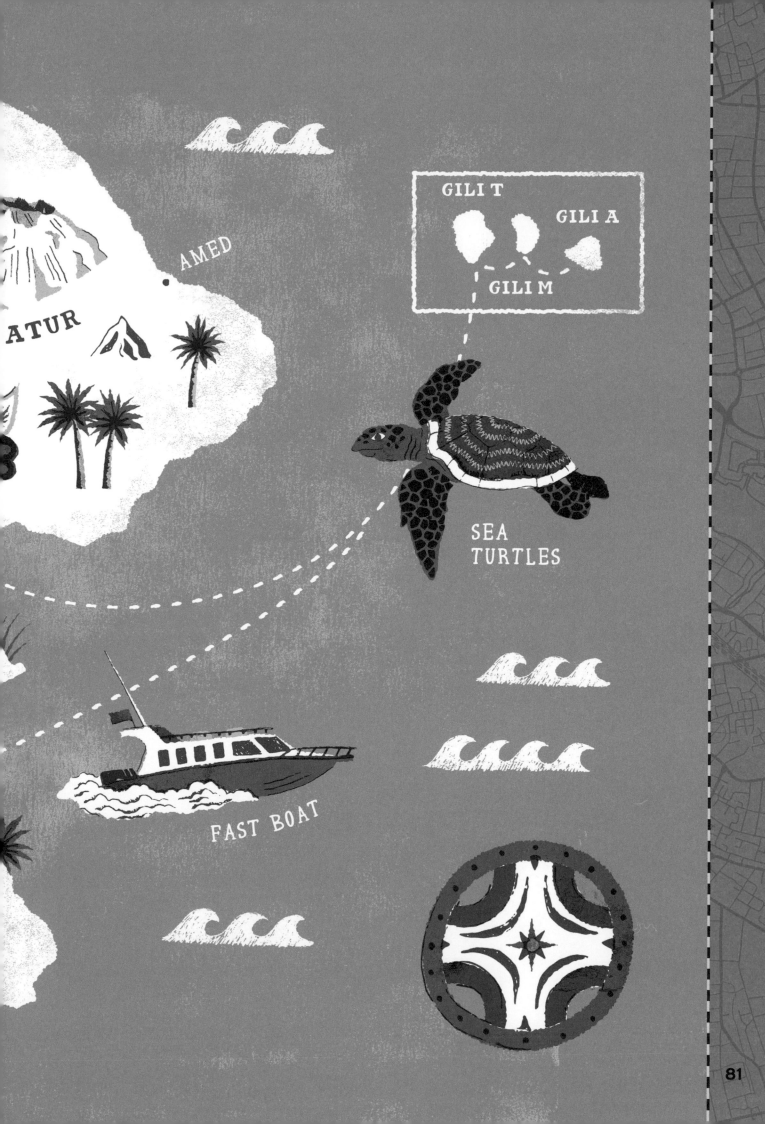

GILI T

GILI A

GILI M

AMED

ATUR

SEA
TURTLES

FAST BOAT

FATAL CONSEQUENCES

- ROGER McGOUGH

you're a
CATCH!

JAMES GULLIVER HANCOCK

MONTREAL

This is a small map project for the *Wall Street Journal*. When working with a client, I usually receive the briefing for the project in the form of a list of places they want to show within a certain location. In this case, we are working with Montreal, Canada.

When I start a map, I like to jump straight into Google Maps™ and plot places of interest on a real map of the location. This enables you to get a sense of the distances between places, where there are groupings of elements, and generally understand the lay of the land.

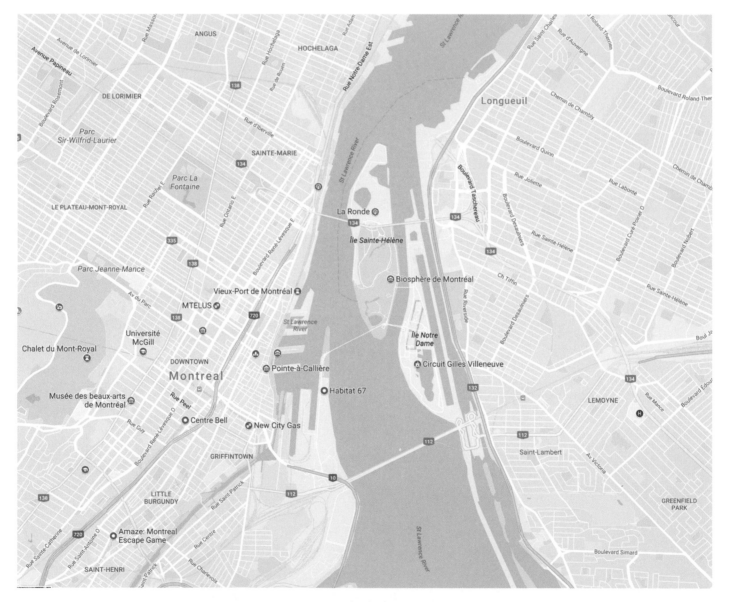

© 2015 Google Inc, used with permission. Google and the Google logo are registered trademarks of Google Inc.

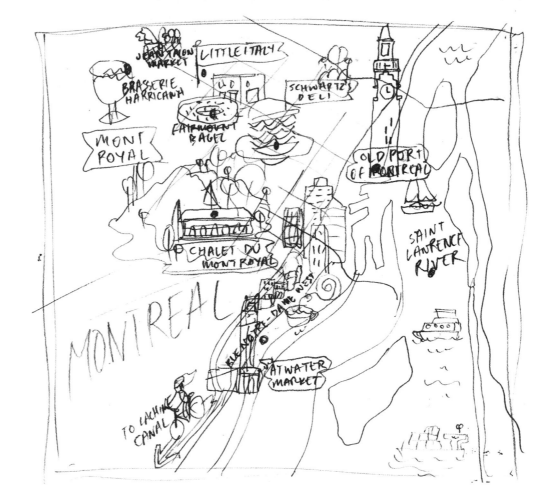

From here, I create a very rough sketch of the full map. I usually need to compress a few of the distances to enable everything to fit. I like to play with scale, which invites people to explore a place, rather than make a map that is 100-percent accurate and able to be used while you walk around. This type of map is more of a starting point and an invitation to explore.

I draw the background of the city and its streets separately, so I can move them around in Photoshop after I scan in the elements.

I use my sketch to trace the final line work of each element. Again, I like to draw everything separately so I have the flexibility within Photoshop to move things around if needed.

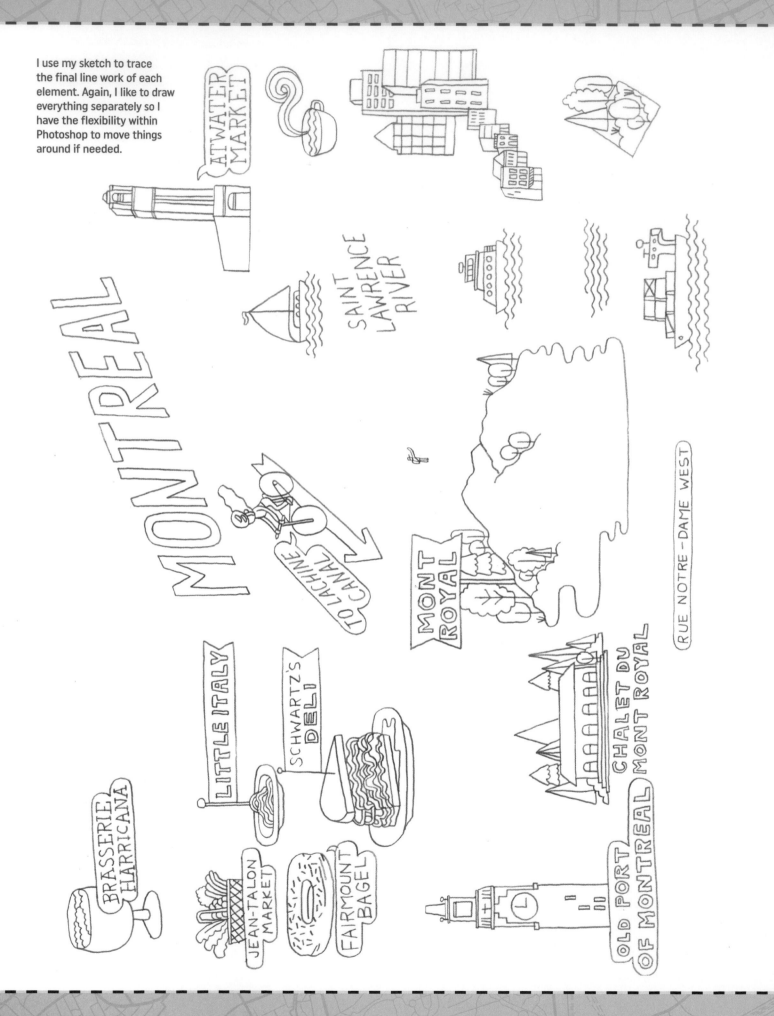

ATWATER MARKET

SAINT LAWRENCE RIVER

MONTREAL

TO LACHINE CANAL

MONT ROYAL

RUE NOTRE–DAME WEST

LITTLE ITALY

SCHWARTZ'S DELI

CHALET DU MONT ROYAL

BRASSERIE HARRICANA

JEAN-TALON MARKET

FAIRMOUNT BAGEL

OLD PORT OF MONTREAL

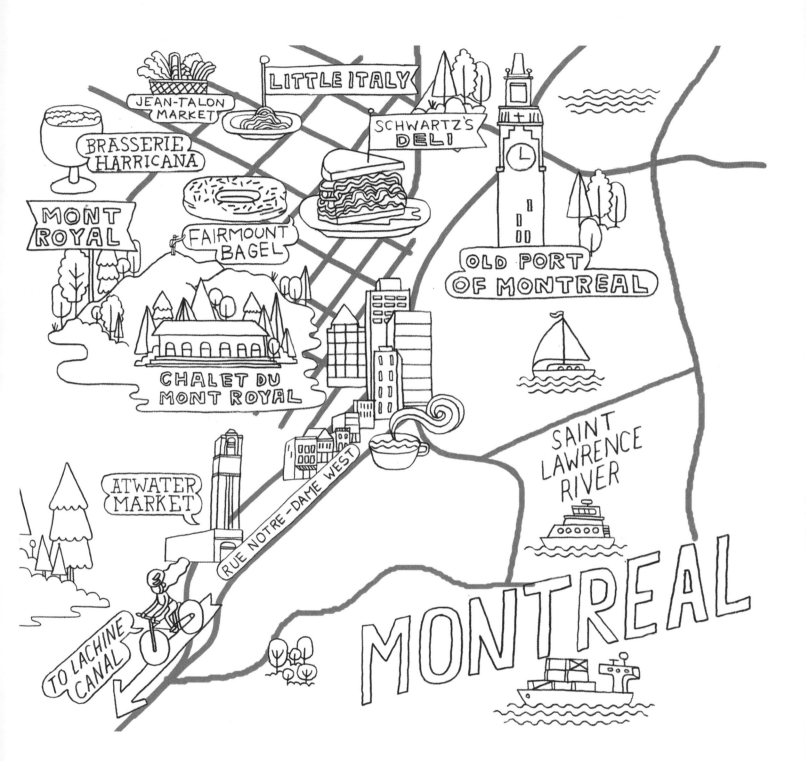

Once I've scanned all these drawings into Photoshop, I start laying them out. I place the streets and water outlines first to set the area I'm working within. Then I bring in all the individual pieces and elements of the map, setting each item on its own layer so I can tweak the placement as I go.

JEAN-TALON
MARKET

BRASSERIE
HARRICANA

MONT
ROYAL

FAIRMOUNT
BAGEL

CHALET DU
MONT ROYA

ATWATER
MARKET

RUE NOTRE

TO LACHINE
CANAL

Once I am happy with where everything sits, I move on to color. I flatten all the line work onto one layer, and work on adding color by selecting individual areas and filling them, using the bucket and brush tools.

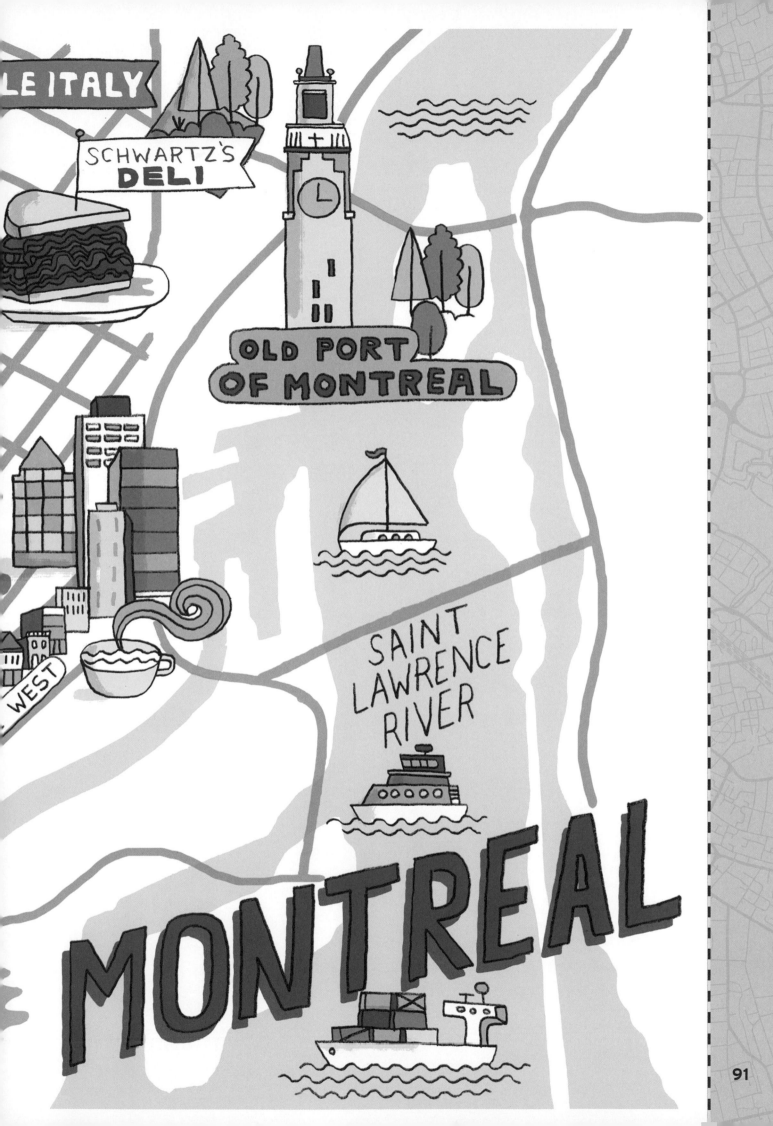

SOLAR SYSTEM

What I find so interesting about maps is the freedom and flexibility to rearrange information. I love it when maps are playful in the way they present facts, so that they invite you to rediscover things you already know. It's interesting how far you can push the idea you are trying to communicate in a map and still have it convey meaning. This solar system map is a perfect example of this approach.

A great place to start when making a map of a well-known place like the solar system is to have a look at what is out there. I sketch what I know as one of the classic arrangements of the planets around the sun, sort of showing the scale, and mostly how massive the sun is.

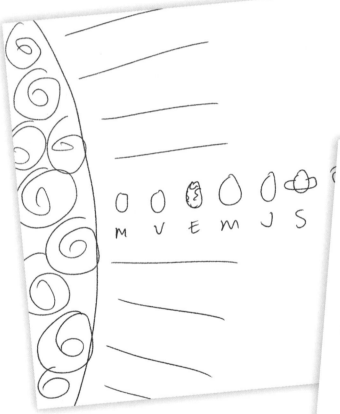

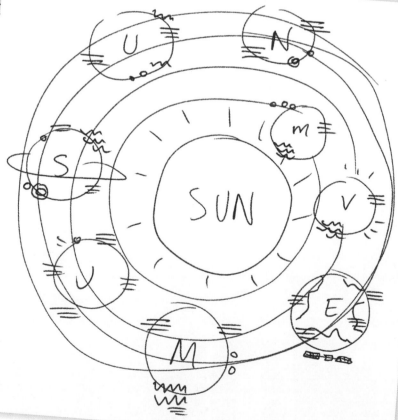

Next feel free to experiment and play with the information. We all know the planets differ greatly in scale, but I thought I could eliminate that concept, and maybe convey them as a tight group of friends hanging out around the sun. I knew I wanted to include a fair bit of readable information within the map—real facts as points of exploration within a playful framework. I sketch that idea out, with little squiggles around each planet.

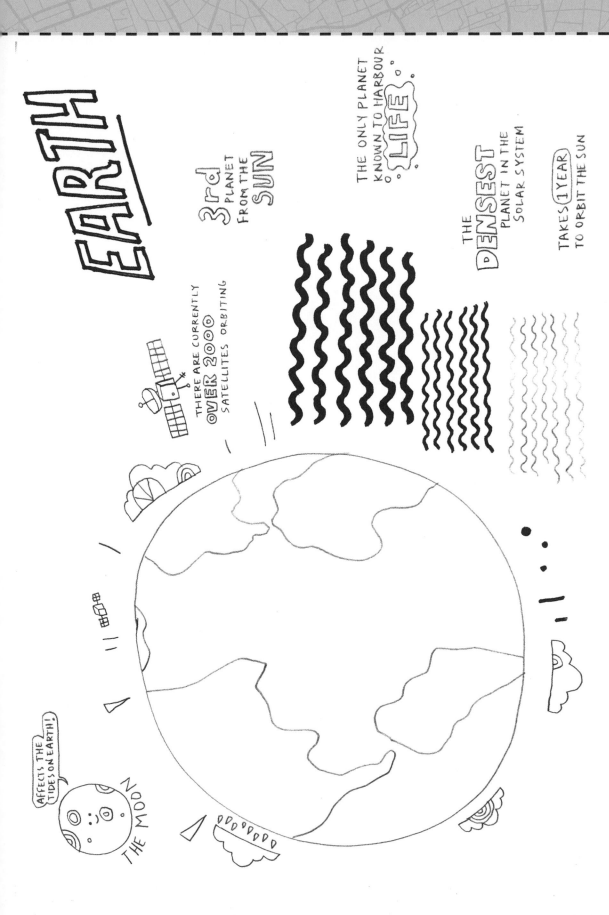

EARTH

3rd PLANET FROM THE **SUN**

THE ONLY PLANET KNOWN TO HARBOUR **LIFE**

THE **DENSEST** PLANET IN THE SOLAR SYSTEM

TAKES 1 YEAR TO ORBIT THE SUN

THERE ARE CURRENTLY **OVER 2000** SATELLITES ORBITING

AFFECTS THE TIDES ON EARTH!

THE MOON

Once you've worked out your ideas and concept, start developing the details. I was excited about my concept and jumped right into final line work. I want to keep it quite loose, so I hand draw the planets and facts with a variety of media, including pencils, brush pens, and markers. If you plan to complete your map digitally like me, keep everything separate on the page so you can arrange the elements later.

It's great to pick information that strikes a chord with you personally, rather than just the main known facts and numbers. For each planet, I create a tabloid-size page with a textural exploration of the surface, a hand-drawn typographic exploration of the planet name, and the text. I love doing research for this kind of project, jumping around through old books I have on the subject and the Internet to find tidbits of information I find interesting.

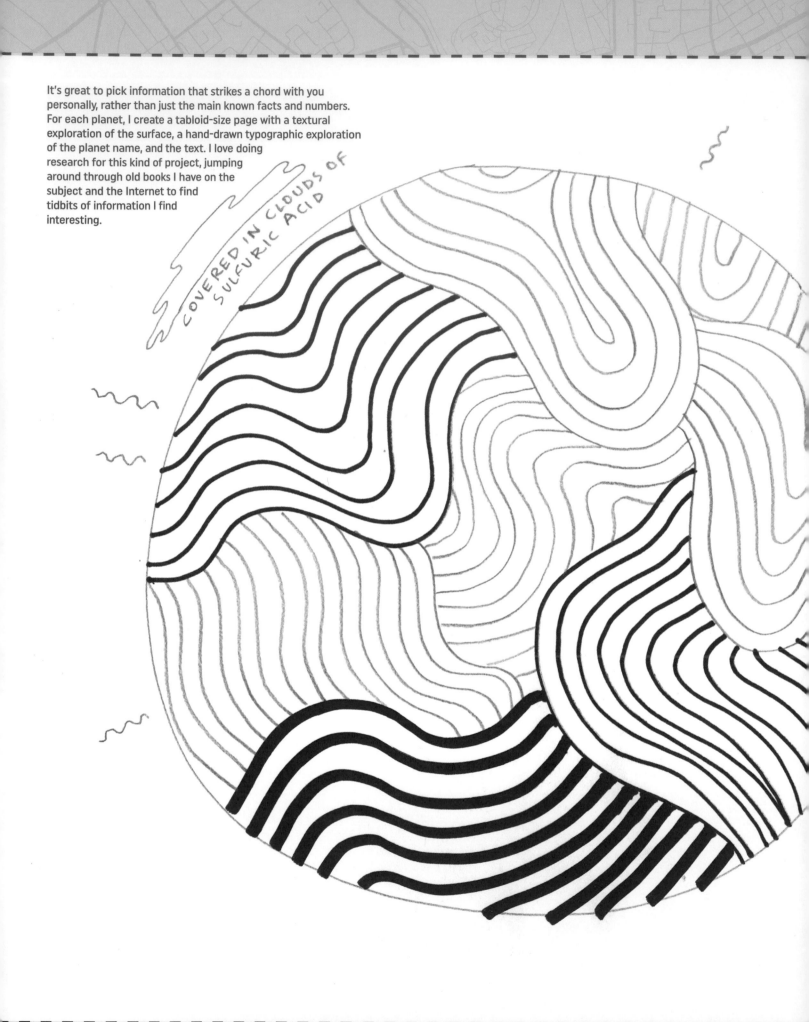

COVERED IN CLOUDS OF SULFURIC ACID

THE HOTTEST

PLANET IN THE
SOLAR SYSTEM

VENUS

SIMILAR
SIZE TO
EARTH

the 2nd

PLANET FROM
THE SUN

ITS ATMOSPHERE IS
96% CARBON
DIOXIDE

T TAKES THE LONGEST
O ROTATE & SPINS IN
HE OPPOSITE DIRECTION
O MOST OTHER PLANETS.

I also hand draw and collage some extra textures and patterns. I use these for some planet surfaces, instead of drawing a new one for each planet. It's great to have things like this on hand to integrate into projects when you need them. I like to keep a big folder of things like this in my studio and scanned into my computer.

EARTH

3rd PLANET FROM THE **SUN**

TAKES 1 YEAR TO ORBIT THE SUN

THE **DENSEST** PLANET IN THE SOLAR SYSTEM

THERE ARE CURRENTLY **OVER 2000** SATELLITES ORBITING

AFFECTS THE TIDES ON EARTH!

THE MOON

APOLLO WAS THE FIRST MAN-MADE CRAFT TO LAND ON THE MOON.

THE ONLY PLANET KNOWN TO HARBOUR **LIFE**

Work on each piece of the map individually to create the final line work and add color. I treat each planet like a two-color silk-screen setup, with black lines and the background color—each is on its own layer in Photoshop to create a nice overlay effect.

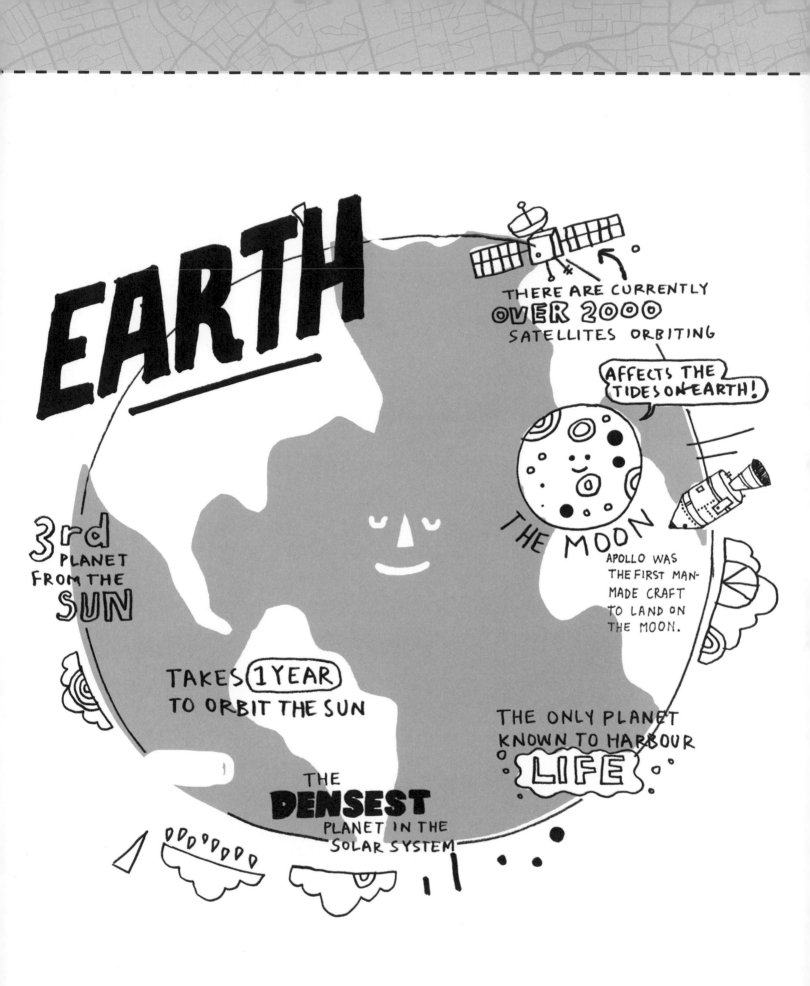

EARTH

THERE ARE CURRENTLY **OVER 2000** SATELLITES ORBITING

AFFECTS THE TIDES ON EARTH!

THE MOON

APOLLO WAS THE FIRST MAN-MADE CRAFT TO LAND ON THE MOON.

3rd PLANET FROM THE SUN

TAKES 1 YEAR TO ORBIT THE SUN

THE ONLY PLANET KNOWN TO HARBOUR LIFE

THE **DENSEST** PLANET IN THE SOLAR SYSTEM

Once all the pieces are complete, bring them together if you're working digitally. Here I bring each plant together on one document and arrange them around the sun.

What I love about this piece is that there are levels to experience. The quirky type, fun colors, and little faces draw in the viewer. Upon realizing it's the solar system, it might almost hurt the brain a little that things aren't the right scale—or even close—then you are drawn in again by the facts, and the learning and wonder begins.

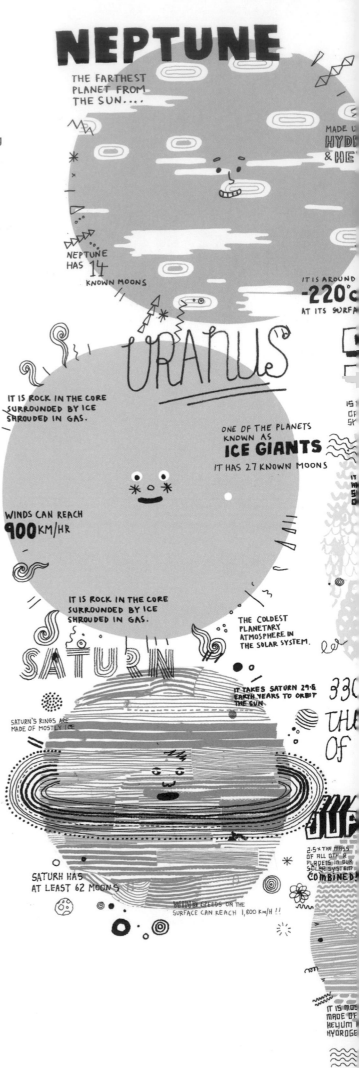

NEPTUNE

THE FARTHEST PLANET FROM THE SUN....

MADE U
HYD
& HE

IT IS AROUND
-220°c
AT ITS SURFA

NEPTUNE HAS 14 KNOWN MOONS

URANUS

IT IS ROCK IN THE CORE SURROUNDED BY ICE SHROUDED IN GAS.

ONE OF THE PLANETS KNOWN AS
ICE GIANTS
IT HAS 27 KNOWN MOONS

WINDS CAN REACH
900 KM/HR

IT IS ROCK IN THE CORE SURROUNDED BY ICE SHROUDED IN GAS.

THE COLDEST PLANETARY ATMOSPHERE IN THE SOLAR SYSTEM.

SATURN

IT TAKES SATURN 29·5 EARTH YEARS TO ORBIT THE SUN

SATURN'S RINGS ARE MADE OF MOSTLY ICE

2·5× THE MASS OF ALL OTHER PLANETS IN OUR SOLAR SYSTEM COMBINED!

SATURN HAS AT LEAST 62 MOONS

WIND SPEEDS ON THE SURFACE CAN REACH 1,800 KM/H !!

IT IS MOS
MADE OF
HELIUM
HYDROGE

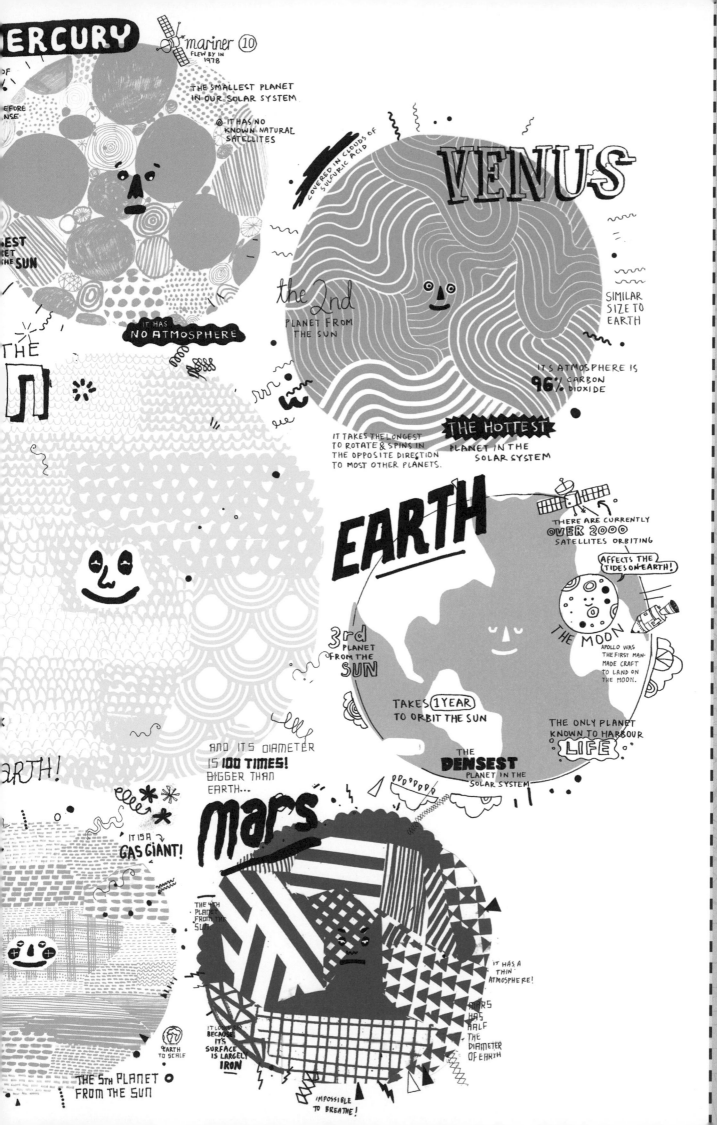

ERCURY

mariner ⑩
FLEW BY IN 1978

THE SMALLEST PLANET IN OUR SOLAR SYSTEM

• IT HAS NO KNOWN NATURAL SATELLITES

IT HAS NO ATMOSPHERE

THE SUN

VENUS

COVERED IN CLOUDS OF SULFURIC ACID

the 2nd
PLANET FROM THE SUN

SIMILAR SIZE TO EARTH

ITS ATMOSPHERE IS 96% CARBON DIOXIDE

THE HOTTEST PLANET IN THE SOLAR SYSTEM

IT TAKES THE LONGEST TO ROTATE & SPINS IN THE OPPOSITE DIRECTION TO MOST OTHER PLANETS.

EARTH

THERE ARE CURRENTLY OVER 2000 SATELLITES ORBITING

AFFECTS THE TIDES ON EARTH!

THE MOON

APOLLO WAS THE FIRST MAN-MADE CRAFT TO LAND ON THE MOON.

3rd PLANET FROM THE SUN

TAKES 1 YEAR TO ORBIT THE SUN

THE DENSEST PLANET IN THE SOLAR SYSTEM

THE ONLY PLANET KNOWN TO HARBOUR LIFE

AND ITS DIAMETER IS 100 TIMES! BIGGER THAN EARTH...

IT IS A GAS GIANT!

ARTH!

mars

THE 4TH PLANET FROM THE SUN

IT HAS A THIN ATMOSPHERE!

MARS HAS HALF THE DIAMETER OF EARTH

IT LOOKS RED BECAUSE ITS SURFACE IS LARGELY IRON

EARTH TO SCALE

THE 5th PLANET FROM THE SUN

IMPOSSIBLE TO BREATHE!

CHILDHOOD NEIGHBORHOOD

A map is a curated version of reality. To build a map of your neighborhood, it's important to focus on the things that are important to you. Remember—you don't have to draw EVERYTHING. Focus on particular points of interest. A map that shows people your personal version of the world is far more interesting than one that shows the exact location of every street, house, car, shop, etc.

While obsessional maps that showcase everything are also wonderful, when you curate a map with personal insights, it becomes more like a diary of a person (you!) and place. It becomes something that shows other people how you experience a place that is important to you, and it can help you and others embrace a place with much more meaning.

Start by listing the things that are important to you in your neighborhood. They may not necessarily be the same things that a traditional map would deem important, and that's okay! I'm going to do a map of my childhood neighborhood, utilizing both my memory and reference to current maps.

This stage is playful, so just jot down the important things that come to mind without thinking too much about it. You'll figure out how to make it work later.

James' Childhood Neighborhood (From Memory)

—My House
• Pool
• Mango Tree
• Factory Next Door

—School
—Hidden Fort
—Josh's House
—Angus' House
• Propeller

—Lisa's House
—Skate Hill
• Death Wobble

—Ferry
—Bus Stop
—Swings
—Corner Store & Candy!
—Hamburger Store
—Bread Store— Herman
—Kayak

© 2015 Google Inc, used with permission. Google and the Google logo are registered trademarks of Google Inc.

Next I start to map the items on my list on a traditional map. I suggest using an online map service to find locations of things—you can even print it out and scribble on it.

You'll likely notice that there are a lot of things very close to your home, and they spread out the farther away you get. As I've mentioned elsewhere, it's fun to play with those distances and let them expand and contract to make the page more dynamic.

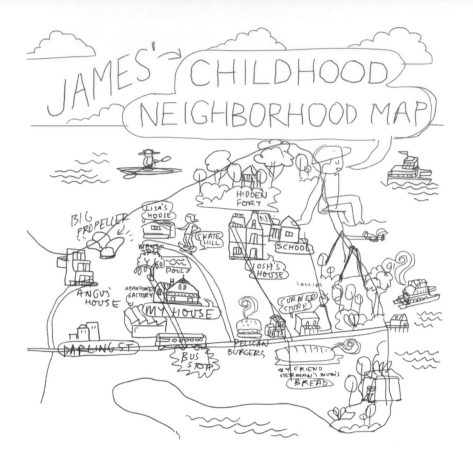

I redraw the map, bringing the farthest things together a bit and making everything sit on the page better. My map is a square format, but you can use any shape. Notice that my map only includes the main streets. Losing a bit of detail to the map is crucial to making it work. At this point, begin to think about would best represent each location—you'll want a small illustration or design and title for each.

Once the rough sketch and its various elements is done, I redraw it for the final piece. Each location becomes a little vignette of that place, with a title and other details to ground them on the page.

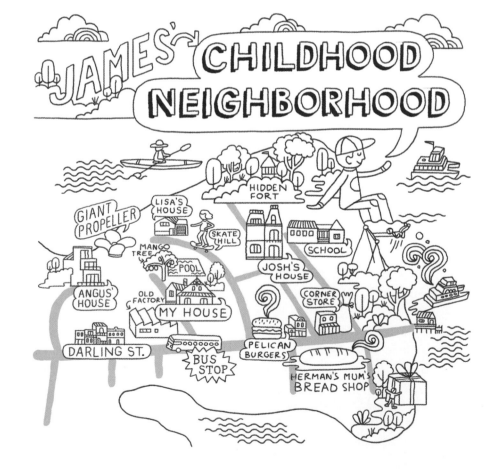

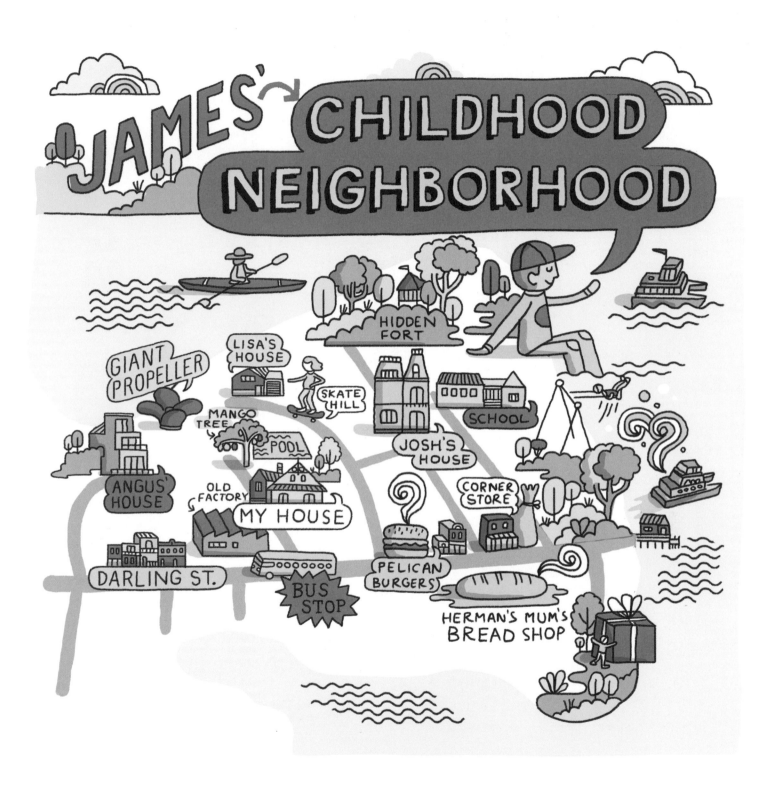

Now I add color to finish the map. I scan my illustrations into the computer and add color digitally, but you can also use watercolor paint, colored pencil, or markers. Just remember to use a waterproof pen if you plan to use water-soluble media like watercolor paint, so the outline doesn't bleed.

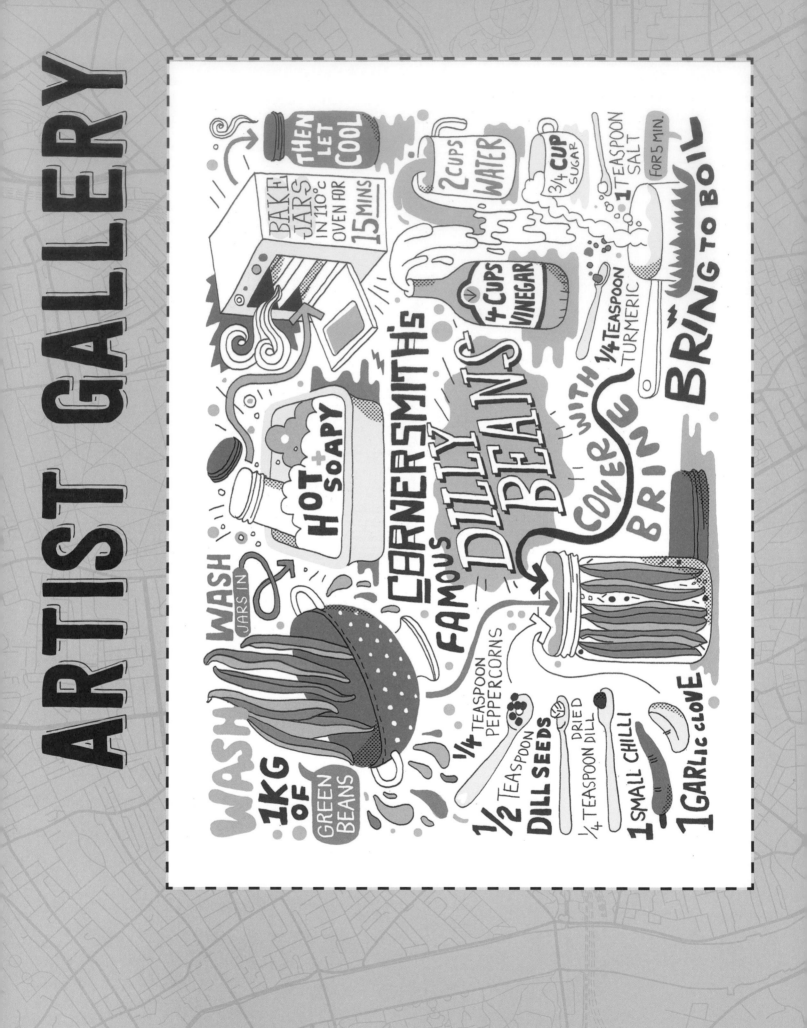

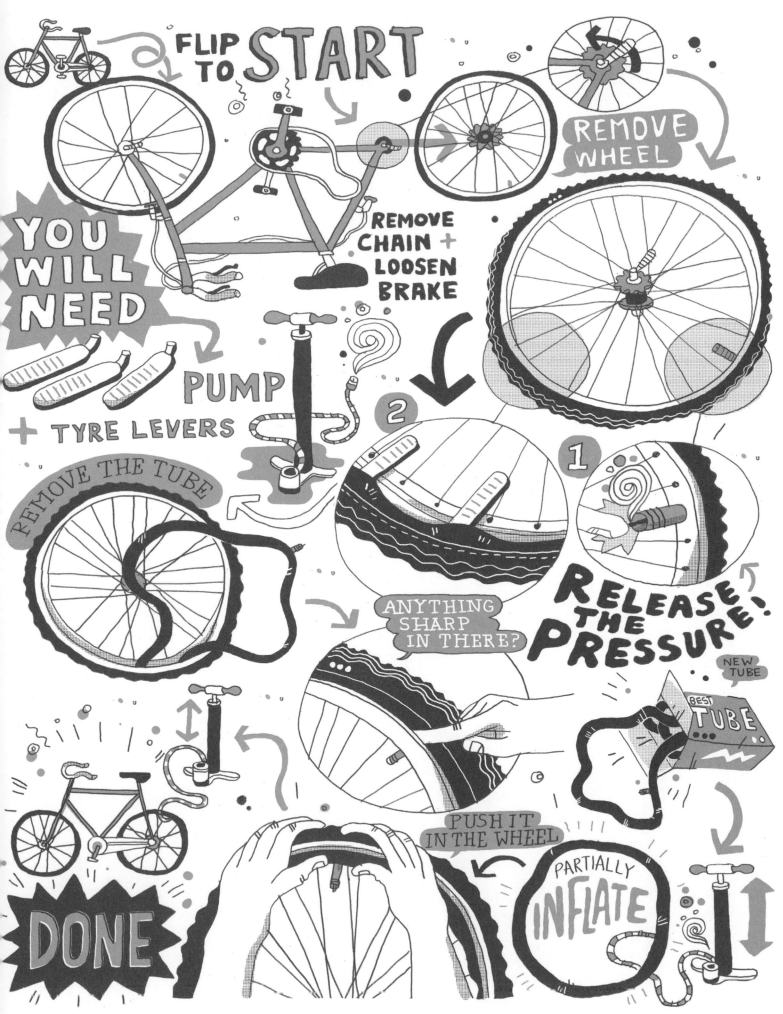

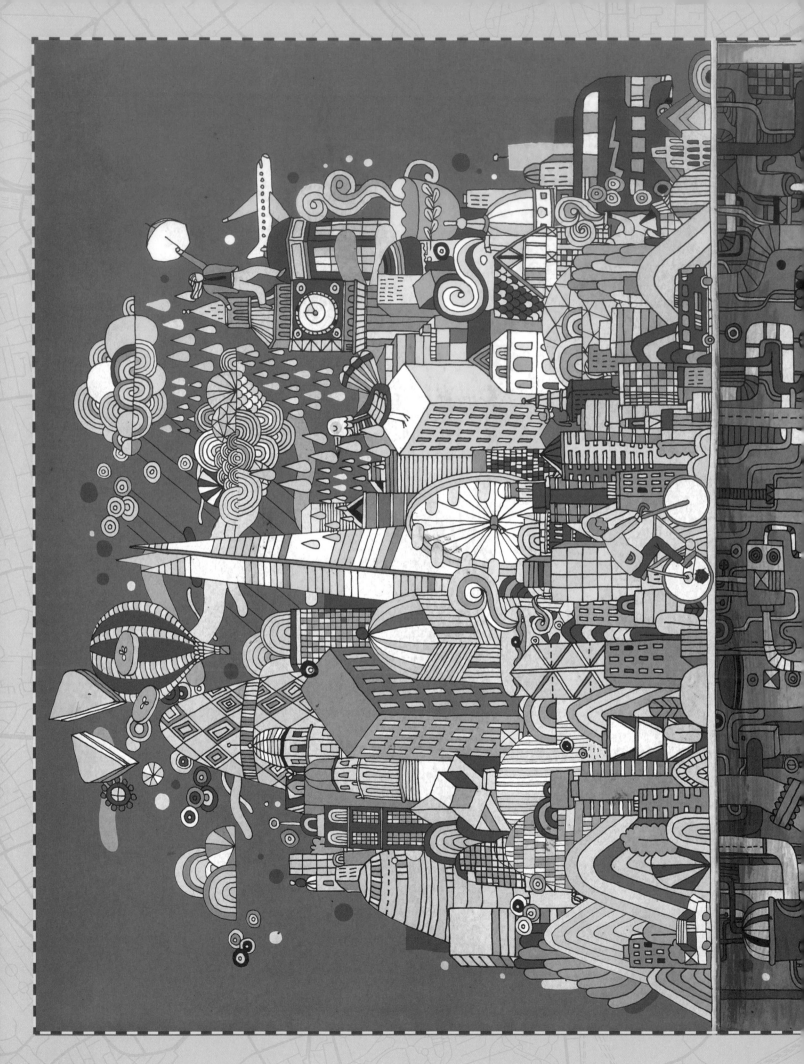

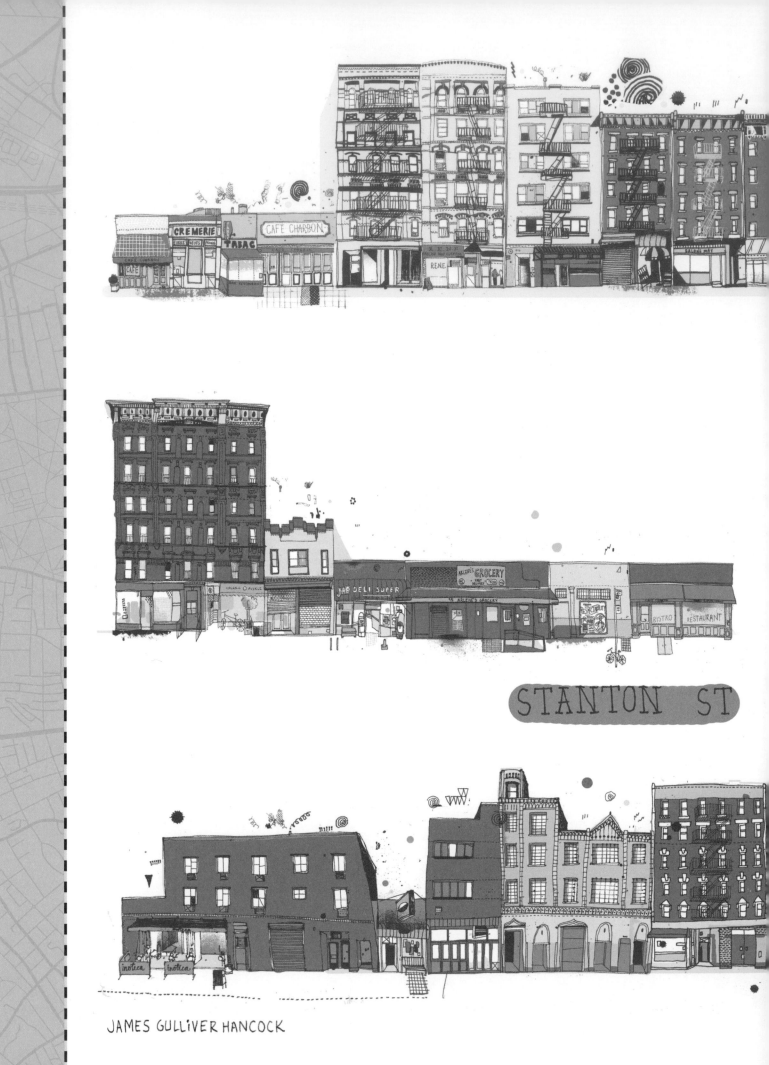

STANTON ST

JAMES GULLIVER HANCOCK

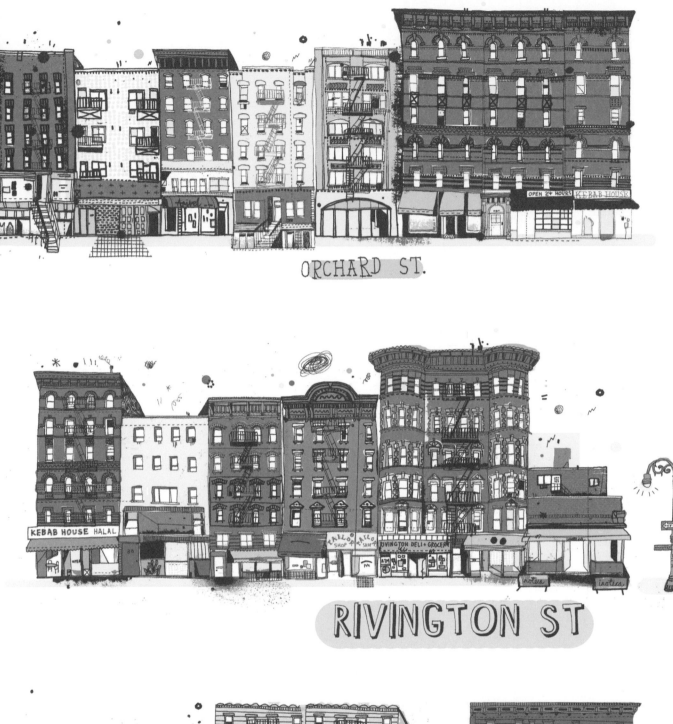

ORCHARD ST.

RIVINGTON ST

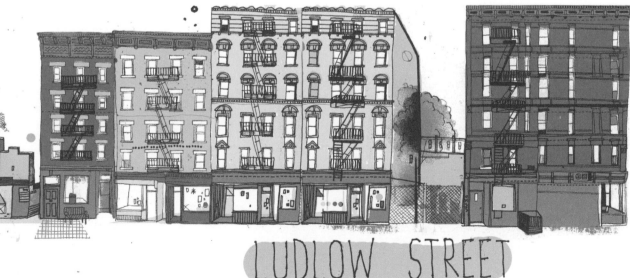

LUDLOW STREET

SARAH
KING

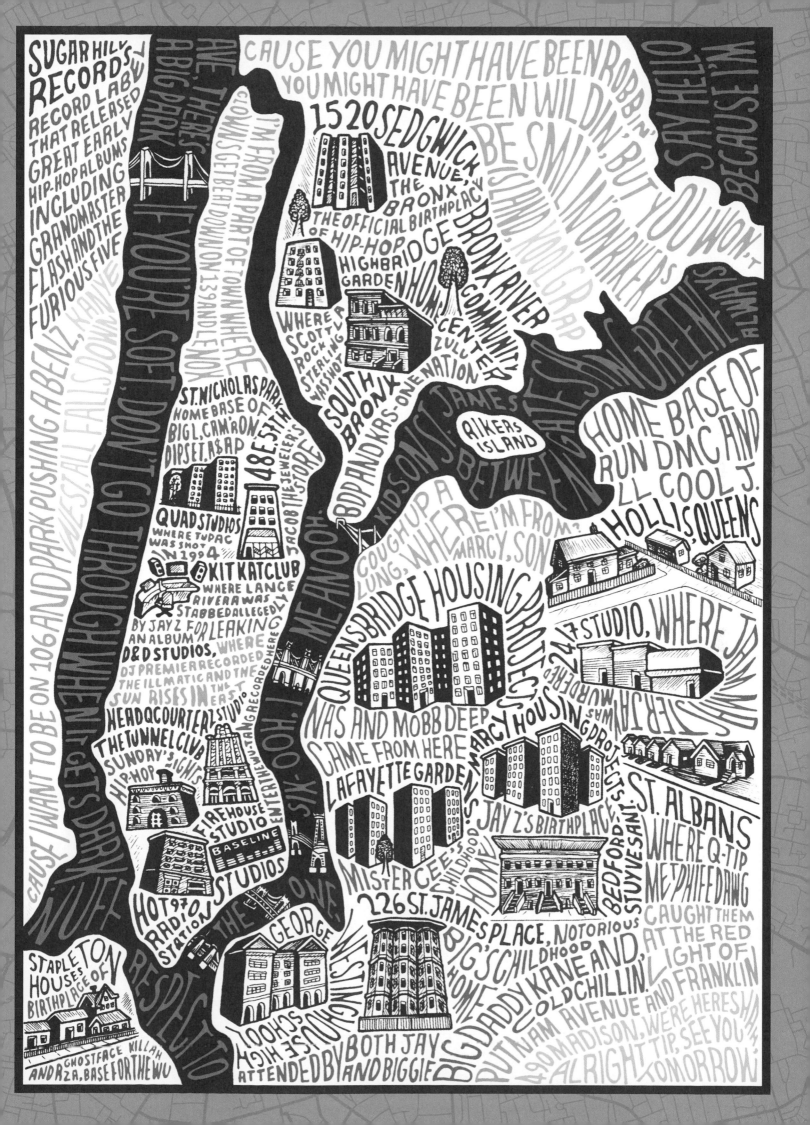

DRAWING TECHNIQUES

There are many ways to approach map illustration. Shown here are some of the techniques I use most often in my own work. Explore these techniques, but don't be afraid to experiment with some of your own too.

Spiky Shading
This can look great and dynamic from a distance. Draw slightly curved spikes of varying depths.

Outlining Words
Sketch the guidelines in pencil first, and then use a fine black drawing pen to outline the text.

Dots
Dots are a good way to shade fine detail with a drawing pen—patience is key! The closer the dots are together, the darker the shading will appear.

Filled-in Words
Use a thicker pen to fill in the words or the background behind the words.

Very Fine Lines
Use a fine-tipped drawing pen to draw very fine lines. This creates more subtle shading.

Thicker Lines
Use a soft black pen. This is a good technique for filling in larger areas of black.

Masking Mistakes
A white paint pen works as an eraser for mistakes made in pen— simply draw over the mistake!

Fine Lines
Create shading with a fine drawing pen.

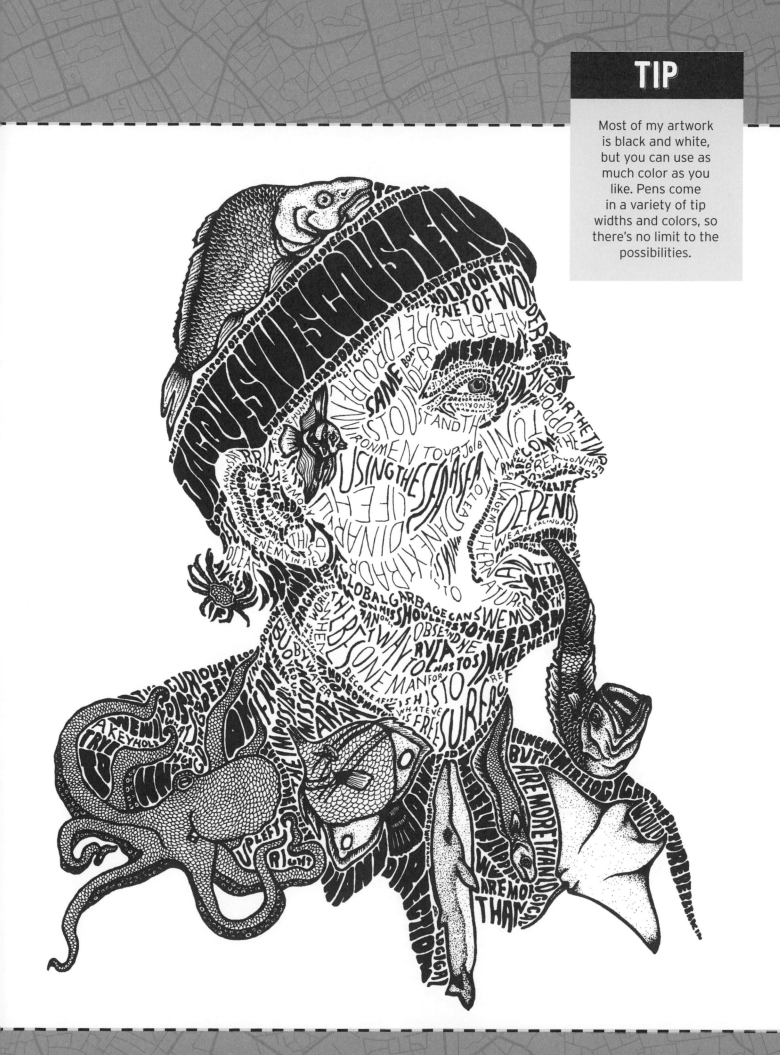

TIP

Most of my artwork is black and white, but you can use as much color as you like. Pens come in a variety of tip widths and colors, so there's no limit to the possibilities.

TOFINO

This map is a mixture of concept and reality. It is inspired by where I live in British Columbia and the surrounding area.

I begin with a small mind map to gather my ideas together and determine the layout of the piece. From this, I chose to reference the layout from an aerial photograph of Tofino and the surrounding area.

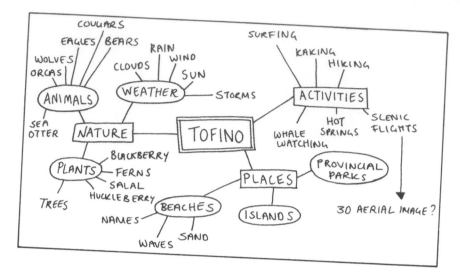

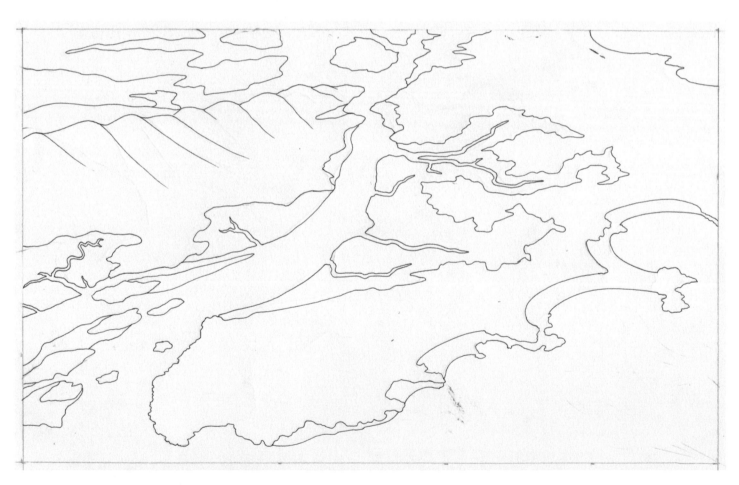

First I create a basic pencil sketch—don't worry if it's very rough. All these lines will be erased. At this point, I don't get too detailed, and try to keep the shapes balanced across the page. Once happy with the pencil sketch, I use a thin drawing pen to trace the outline. This also doesn't have to be perfect, but should be more accurate than the pencil lines, and as smooth as possible to make the later steps easier.

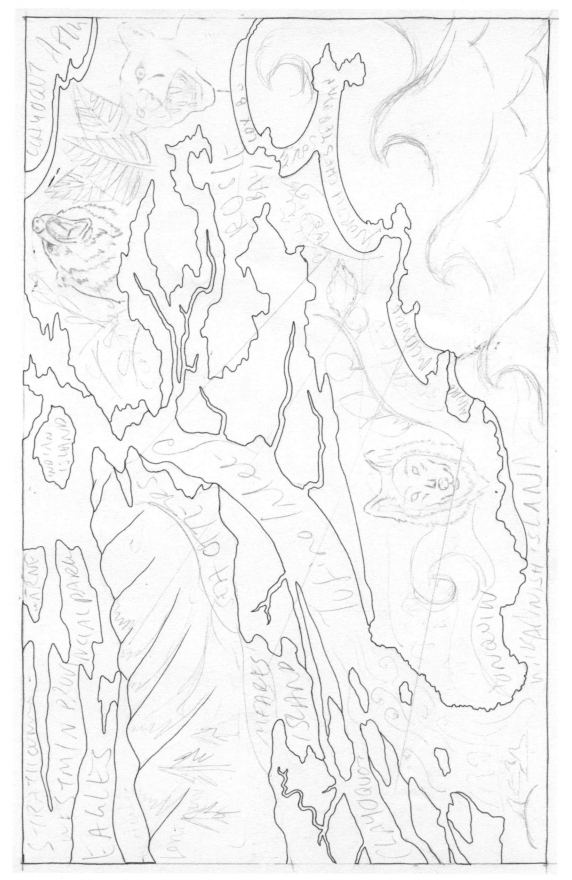

Next I start filling in the content. Keep the imagination flowing and fill in what you can; areas that are empty can be filled in along the way. Use imagery and text from your mind map, research the location you have chosen, and be inspired! This step is quite rough.

Use your handwriting for most of the text—keep it natural. I often draw flowing lines to guide the text. (You can see a small example of this to the left of the wolf.)

TIP

If your words will be white on black, make sure you draw them thick enough to be legible.

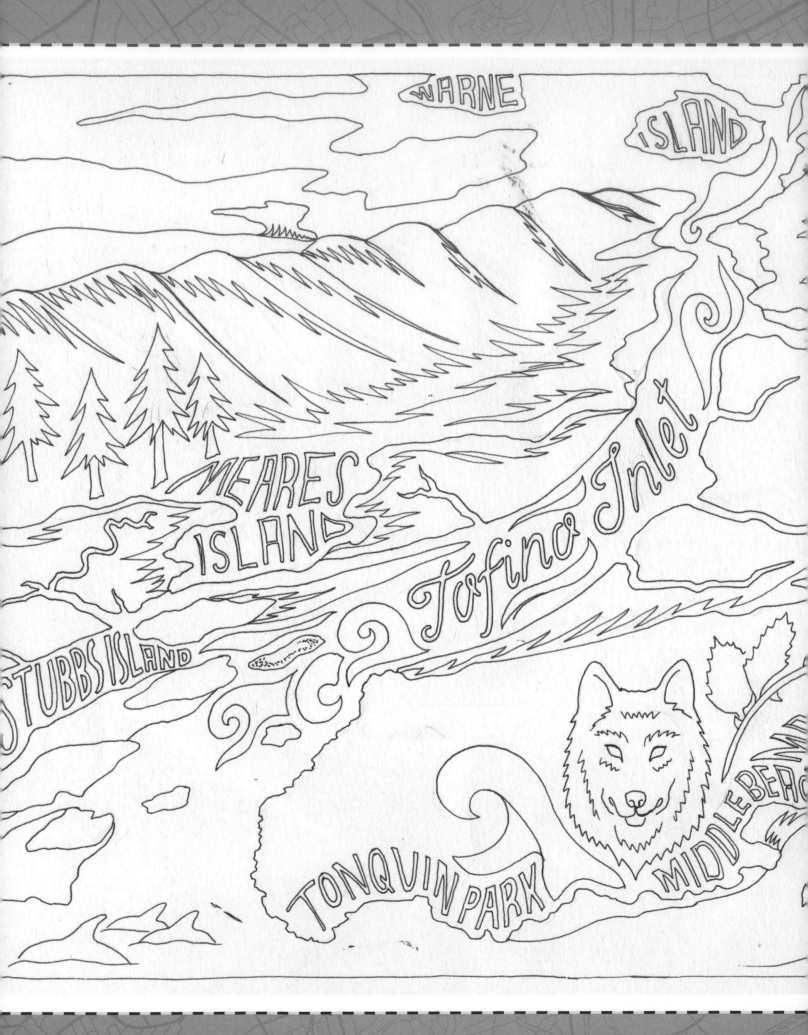

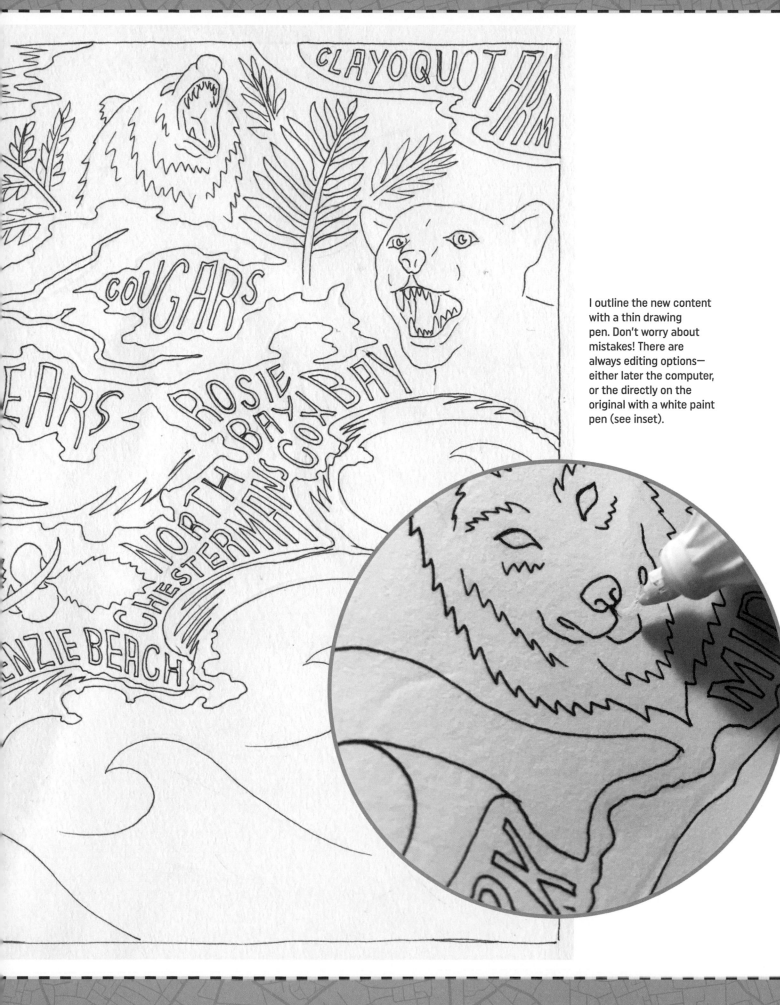

I outline the new content with a thin drawing pen. Don't worry about mistakes! There are always editing options— either later the computer, or the directly on the original with a white paint pen (see inset).

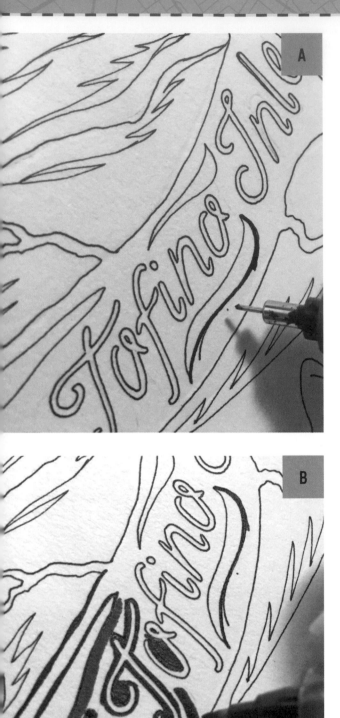

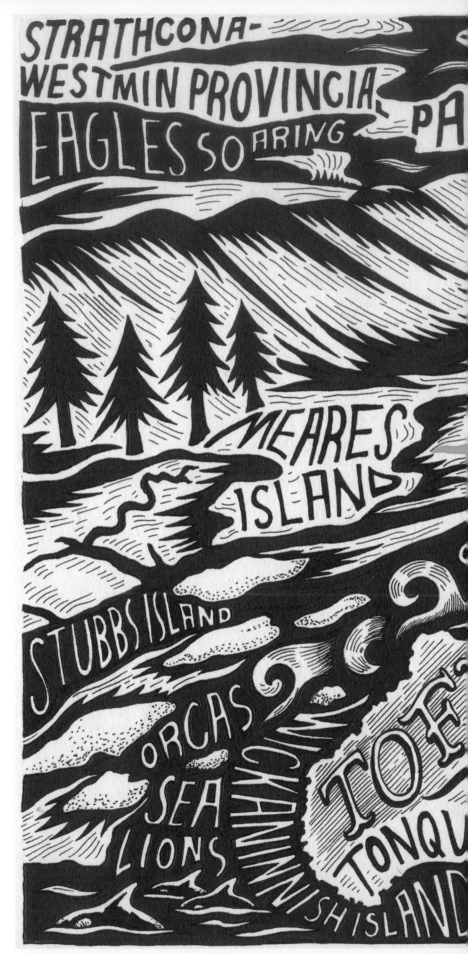

I start filling in the detail. I use a thicker drawing pen to outline the areas to remain white (A) and a firm brush pen to fill in larger black areas (B). With my thin drawing pen, I add detailed fine lines to create texture in the piece.

NE

ISLAND

CLAY

fino Inlet

COUGARS

BEARS

ROSIE
BAY
NORTH
CHESTERMANS COX BA

MACKENZIE BEACH

NO

MIDDLE BEACH

PARK

RF~SEA~SUN~SAND

The filling in and finishing takes the longest amount of time. Be patient, put on some music, and enjoy the process.

Once the illustration is complete, you can decide what you'd like to do with it. Frame the original? Scan it and make prints?

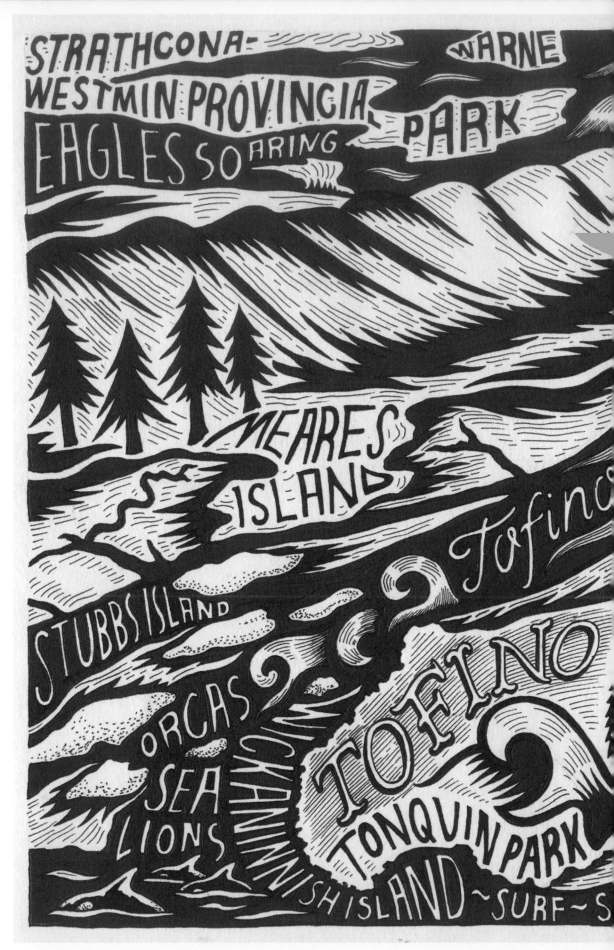

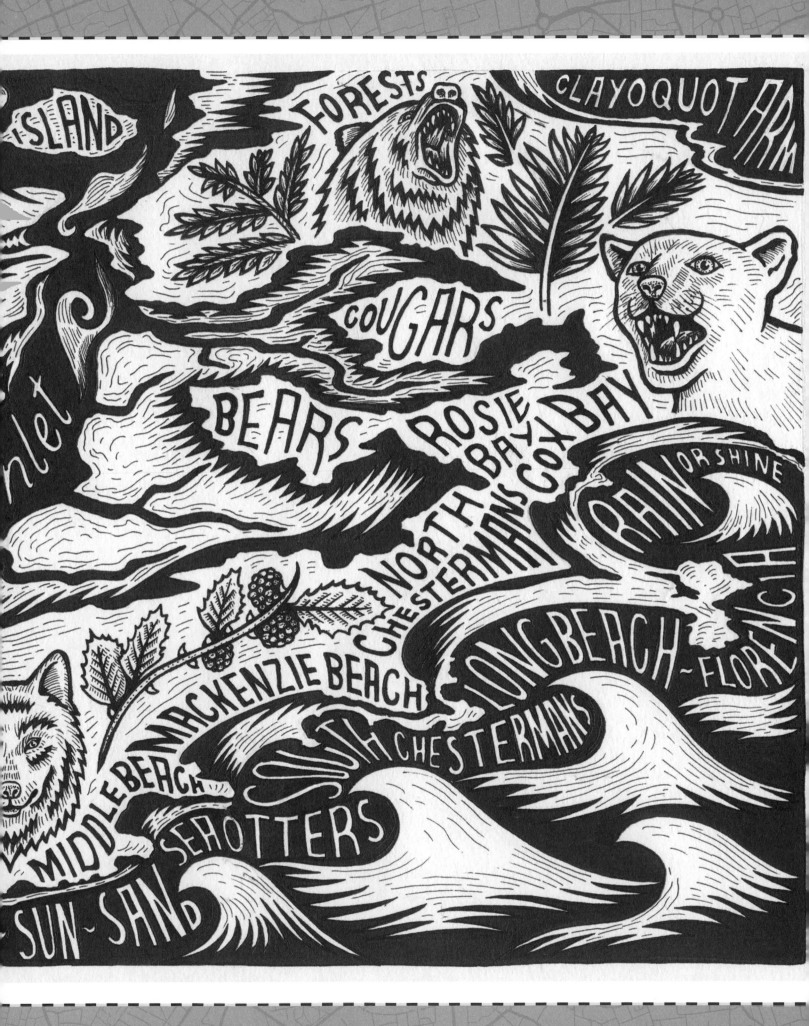

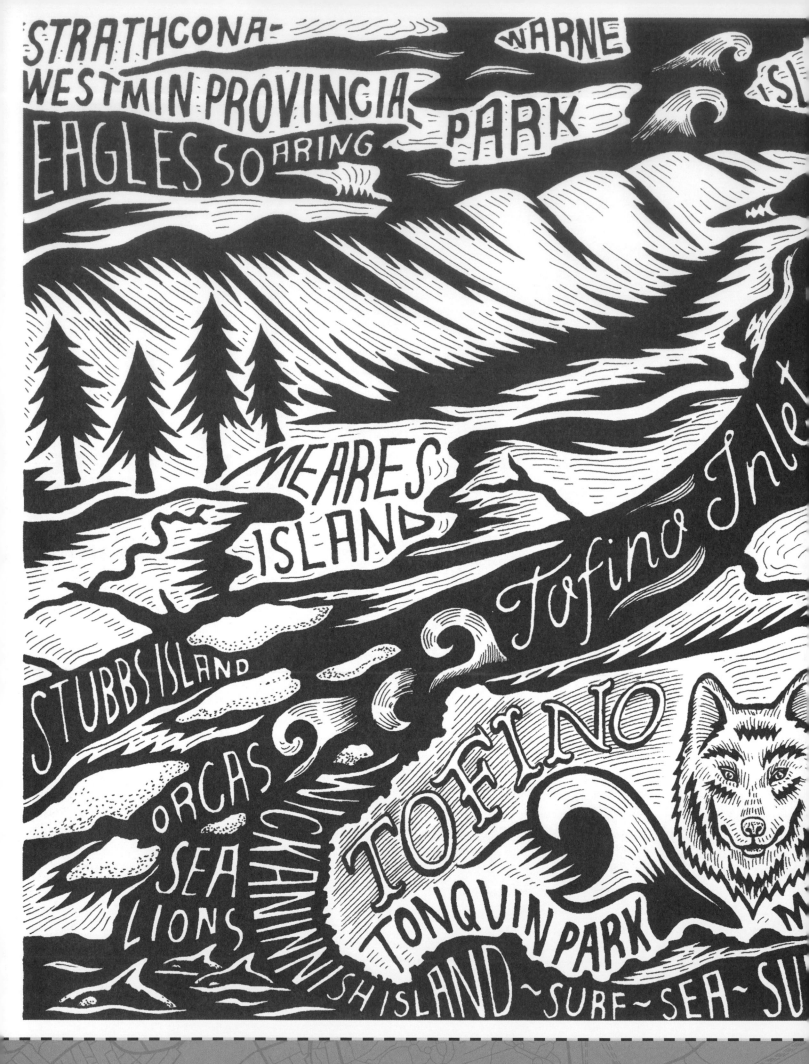

FORESTS
CLAYOQUOT
COUGARS
BEARS
ROSIE BAY
COX BAY
NORTH CHESTERMANS
RAIN OR SHINE
MACKENZIE BEACH
LONG BEACH ~ FLORENCE
SOUTH CHESTERMANS
SEAOTTERS
SAND

If you decide to scan the image like I did, it's helpful to have an image-editing program, such as Adobe Photoshop. With a black-and-white illustration like this, you can easily increase the contrast, which removes evidence of pencil marks or edits made with the white pen for a crisp, clean piece.

BRAIN MAP

The idea for this map came from this anatomical illustration I did a few years ago of a map of the body. This time I wanted to create a map of my brain, using images and words in the correct areas of the brain. I used layouts from traditional illustrated maps of the world as inspiration for the composition.

First I sketch my profile. This can be tricky to do freehand, as you don't often see this side of yourself. I took a photograph, and then outlined the image with tracing paper and transferred it to drawing paper.

TIP

If you use imagery for inspiration, use it as a guide—don't directly copy it, even if it's very old. If it's more recent, or another artist's work, be very careful not to copy—this can get you into trouble! Be inspired, and aim to create your own techniques and develop your own style.

A few notes can be very helpful when it comes to drawing. I did some research on brain diagrams to get an idea of what different functions the various areas of the brain perform.

Your notes can be simple like mine, or you could go into much more detail.

1. VISION
 - Eyes, optical, light, trees, outside

2. LANGUAGE
 - Words, numbers

3. Reading
 - books, words

4. SENSORY INFORMATION
 - TOUCH / TASTE / NOISE / SMELL
 5 6 7 8
 hands, coffee, pizza, music, flowers

9. RECOGNITION
 - faces?

10. MOVEMENT
 - run, snow, surf, bike

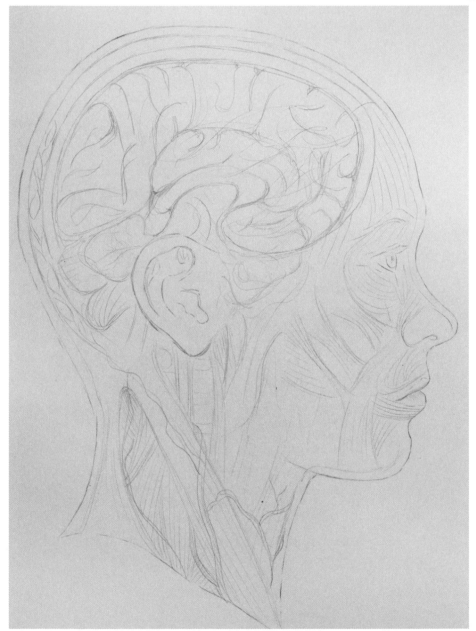

Next I add detail to the portrait. Keep it loose, and fill the head with whatever you like. I decided to use muscles and veins, with a few more imaginary elements.

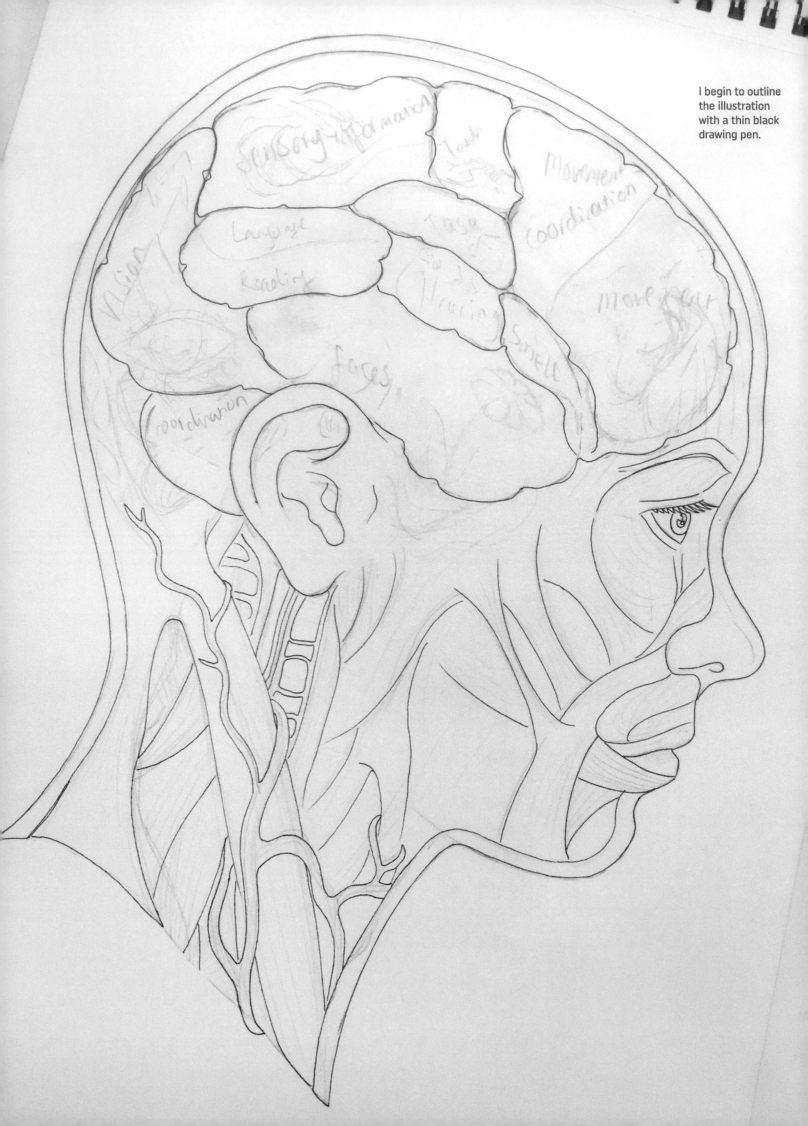

I begin to outline the illustration with a thin black drawing pen.

You can decide on your favorite way to complete the illustration. Sometimes I like to finish all the outlines in a thinner pen before moving on to filling it in with solid color and detail. This time, I'm finishing the illustration as I go along, and adding outlines without too much planning.

Be careful to let the black outline dry completely before erasing pencil lines, and be sure to erase pencil lines before adding color and detail. You can erase pencil later, but it may damage or remove some of the ink.

TIP

Use a small brush pen to fill in black areas more quickly.

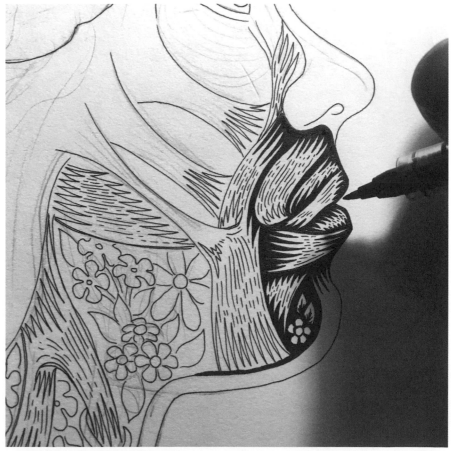

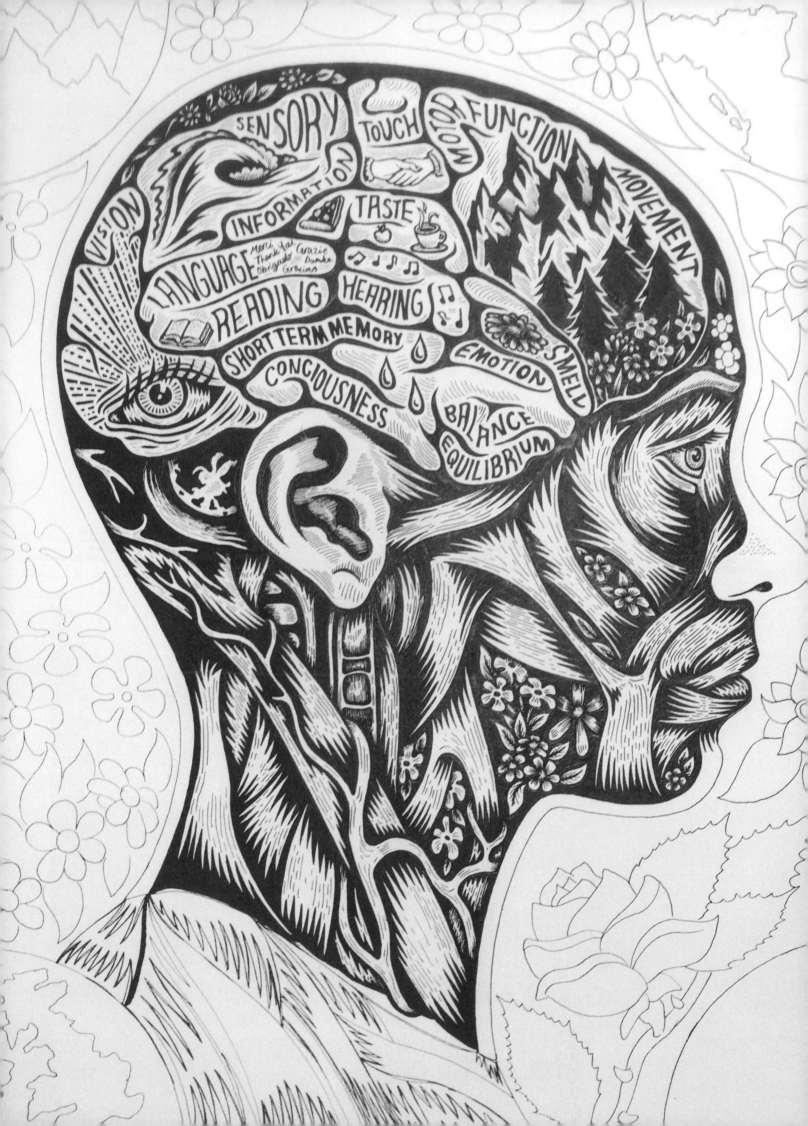

(Opposite) I keep filling in detail, using a brush pen to fill in large areas of black.

I place some circles in the four corners of the page to use as maps of places I have lived: England, where I grew up, and Canada, where I live now. Use this space to draw something personal to you.

Filling in the black background takes some time, but I work carefully on one area at a time, using a brush pen for the larger areas.

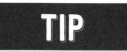

TIP

If you make any mistakes in pen, use a white paint pen to block them out.

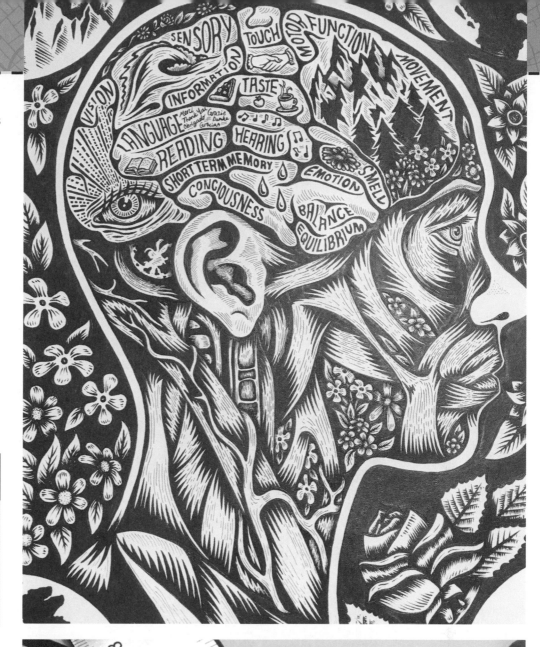

I want to add some longitude and latitude lines to the background of the illustration. I could have included these when drawing the background, but I decided it would be easier to add them at the end. First I measure out even points on the illustration, and mark the center with a larger line.

Next I draw in the lines with a white paint pen, using the marks on the side of the drawing as a guide. Once the paint pen dries, I clean up the edges with a black drawing pen.

TIP

Scan the final illustration and do some basic editing in Photoshop, like I did, so you can no longer see where white paint pen was used to correct mistakes.

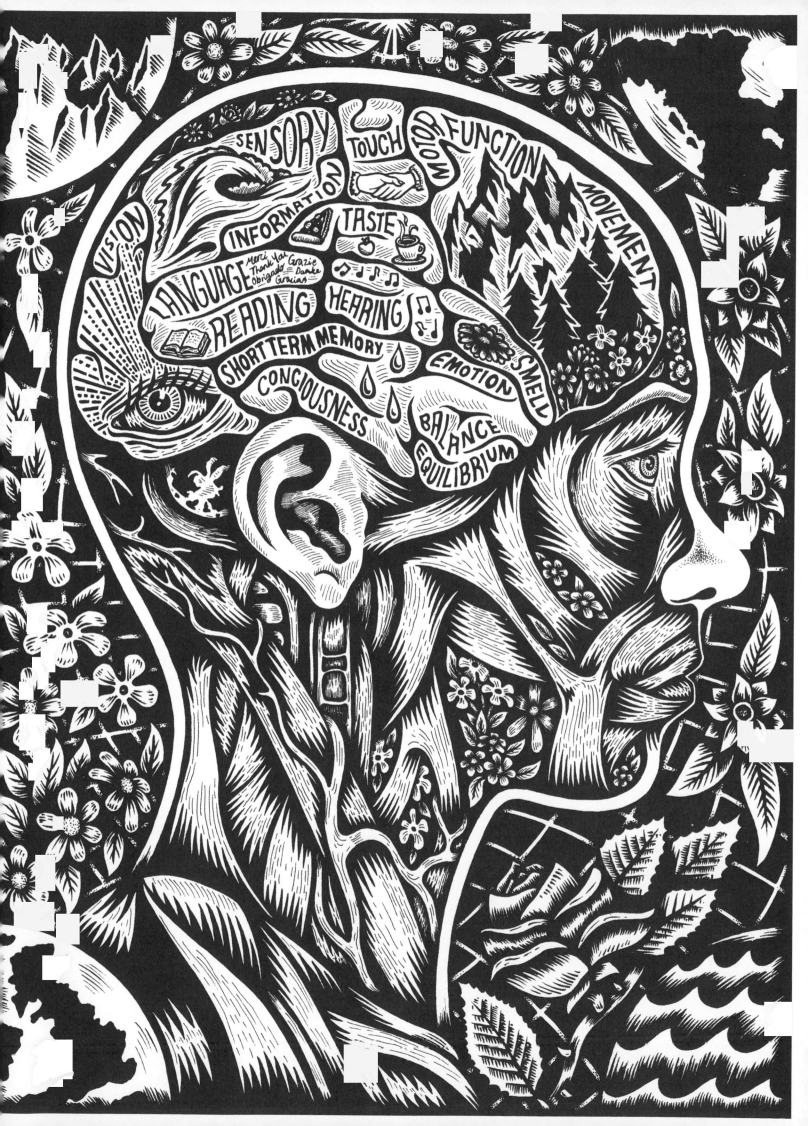

NEW YORK SKYLINE ON WOOD

Painting or drawing the skyline of your favorite city is the perfect way to explore other types of mapmaking. This simple project is easy to create, with dynamic results.

I decide on a skyline of New York City, where I spent three months after I graduated from university. The skyline is based on iconic buildings from around the city.

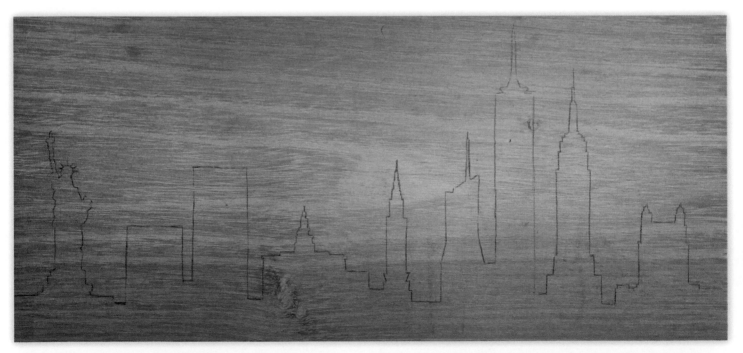

I find a suitable piece of wood and sand it to create a smooth surface. Smooth wood is much easier to draw on—and better for your pens. If you can't find the right piece of wood, you can also work on paper or card! Experiment, and be open to trying different materials. I sketch the skyline onto the wood in pencil.

SELECTING COLORS

I decided to keep art simple—just the wood, black, and white. You might want to explore using a wide spectrum of colors, or even just one color. If you're not sure about your color choice, create a small practice version of your art first. When working with wood, it's best to use water-based, nontoxic paint pens.

Next find your words! Depending on the city and landmarks, brainstorm and create a list of words to incorporate into the skyline. I decided to use the names of buildings in and around New York.

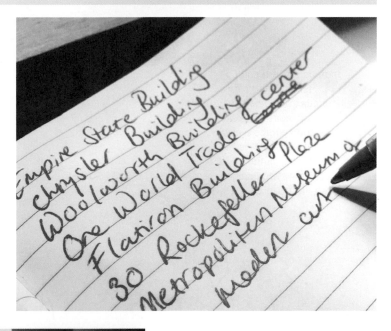

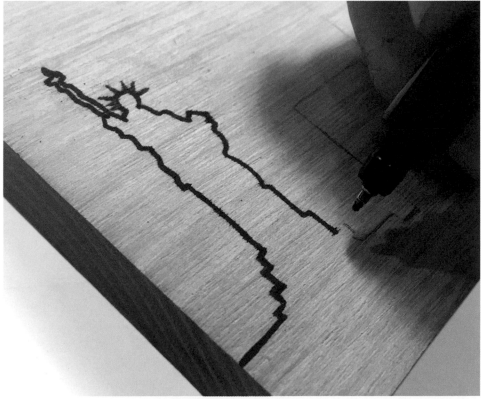

I draw over the pencil skyline with a fine-tipped black paint pen.

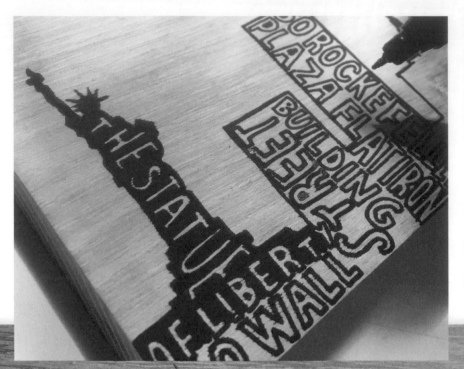

For the text inside the buildings, I use straight lines to outline the letters. You'll want to ensure that the letters are thick enough to allow the wood to show through. If needed, you can sketch the text in pencil before using pen. Then I begin filling in the negative space around the letters.

I continue filling in the negative space around the letters until the whole skyline is filled in. I used a thin pen in tight areas and a thicker pen in larger areas.

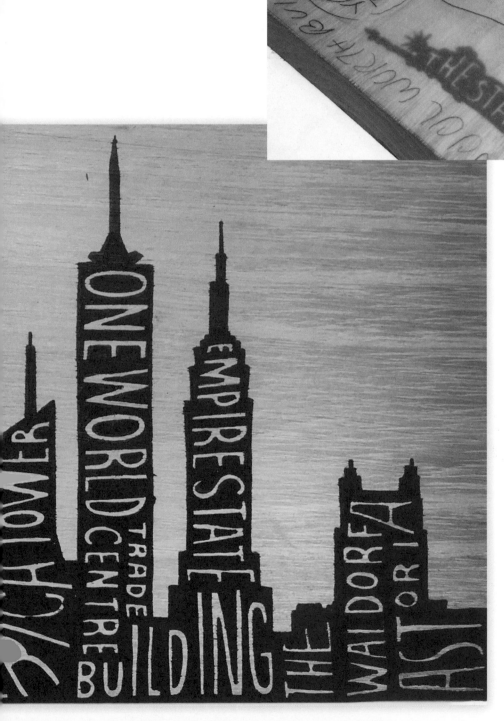

You can stop here, or you can keep going and include the sky in your artwork. For my sky, I want to use a swirlier text, which requires a little more care and planning. I place tracing paper over the wood and sketch some swirls in the sky area. Using tracing paper means I can avoid unnecessary and unwanted pencil lines on the wood.

Next I experiment with words that fit into each swirl shape and write them roughly on the tracing paper.

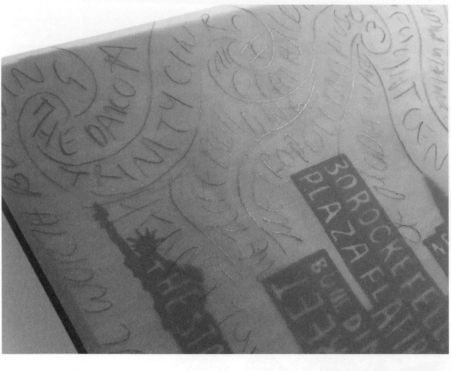

I fill all the swirled shapes with text, which I will use as a guide when I start painting the letters onto the wood.

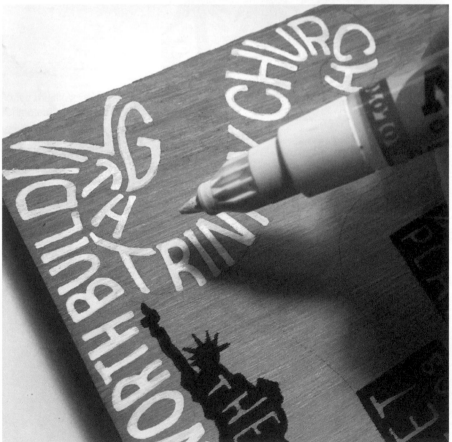

Next I trace just the swirly lines onto the wood—I'll erase these later. Now I can fill in the words! I use the tracing paper as a guide and work with a thin paint pen to keep the letters detailed.

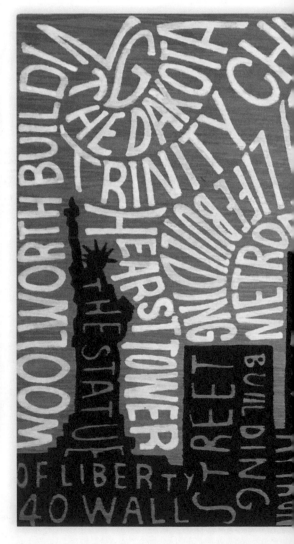

Once the paint pen is dry, I gently erase any visible pencil lines from the wood.

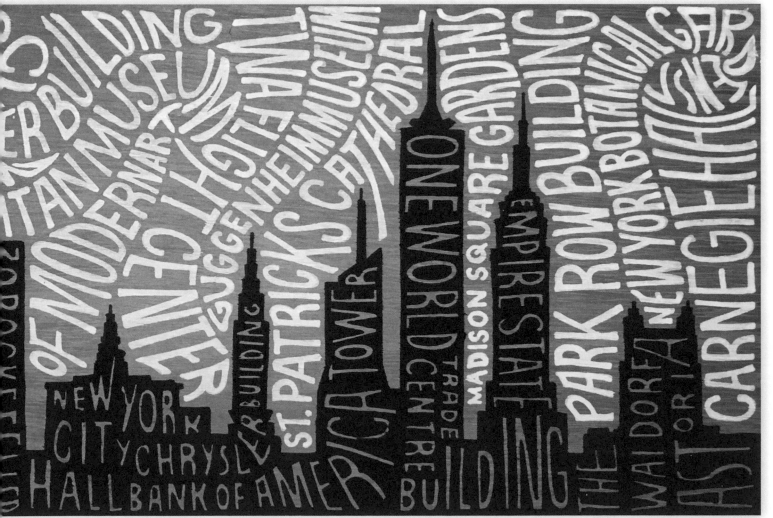

You can leave the finished piece as is, or add a clear coat to protect the illustration. (See pages 138-139.)

I decided to cover this piece with a coat of clear epoxy resin—if you decide to use epoxy resin, make sure you know what you're doing first, and use the appropriate safety wear!

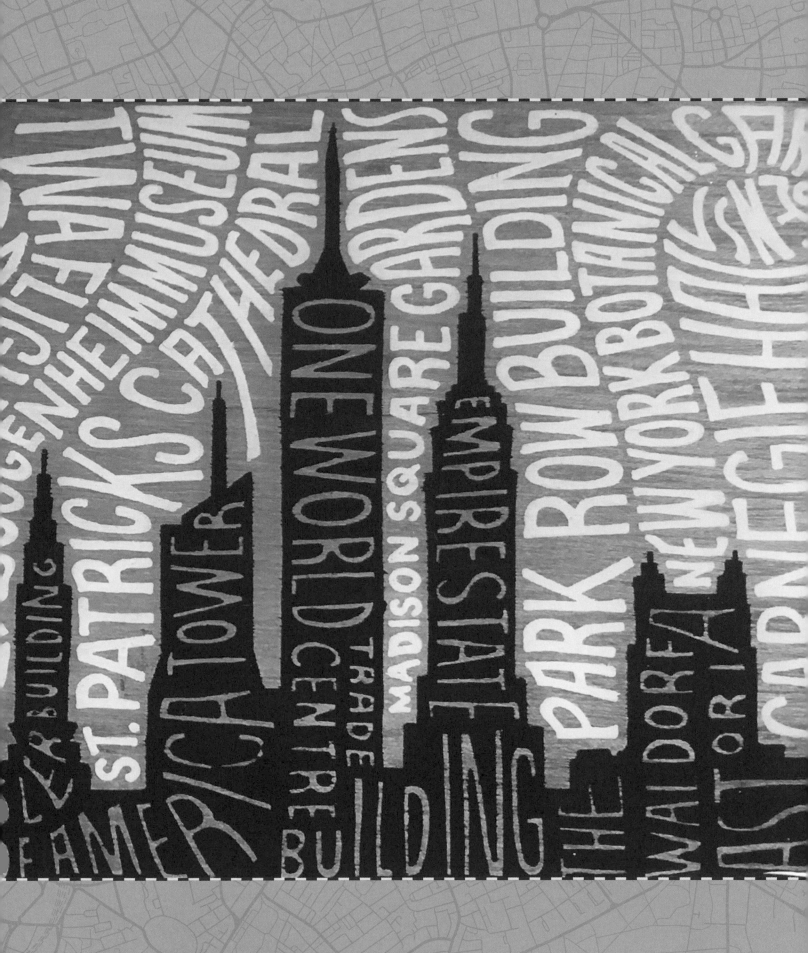

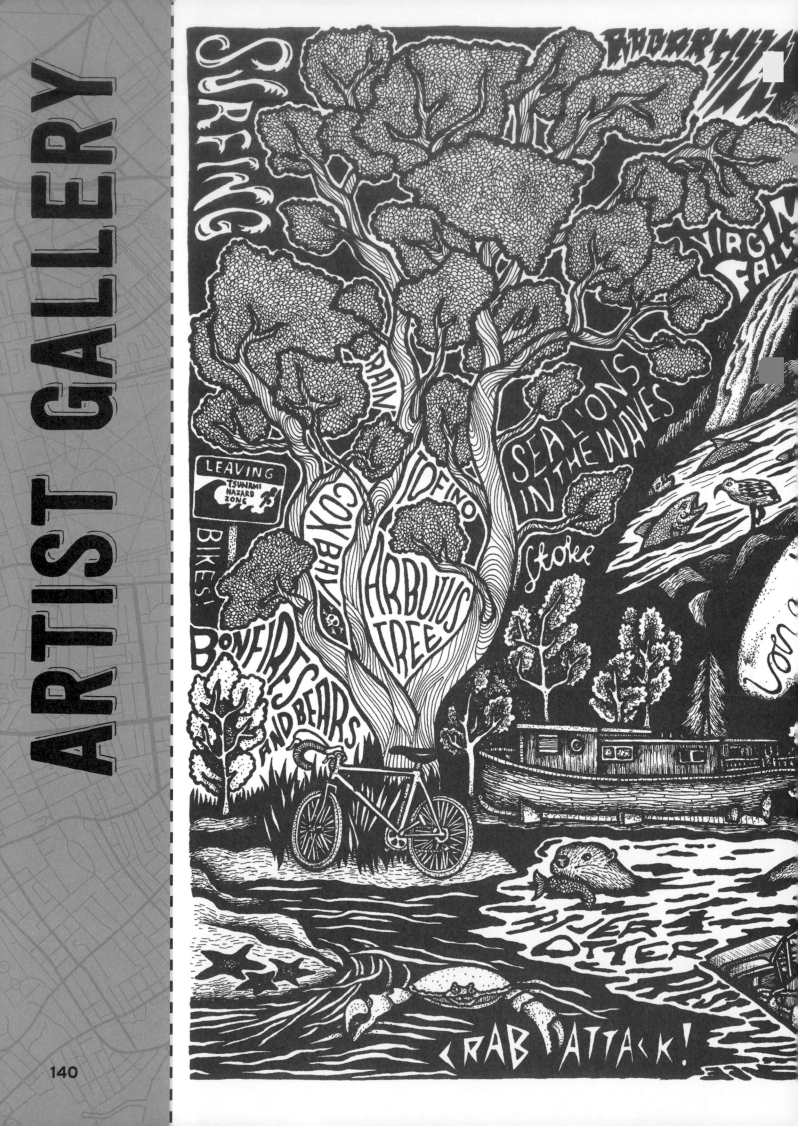

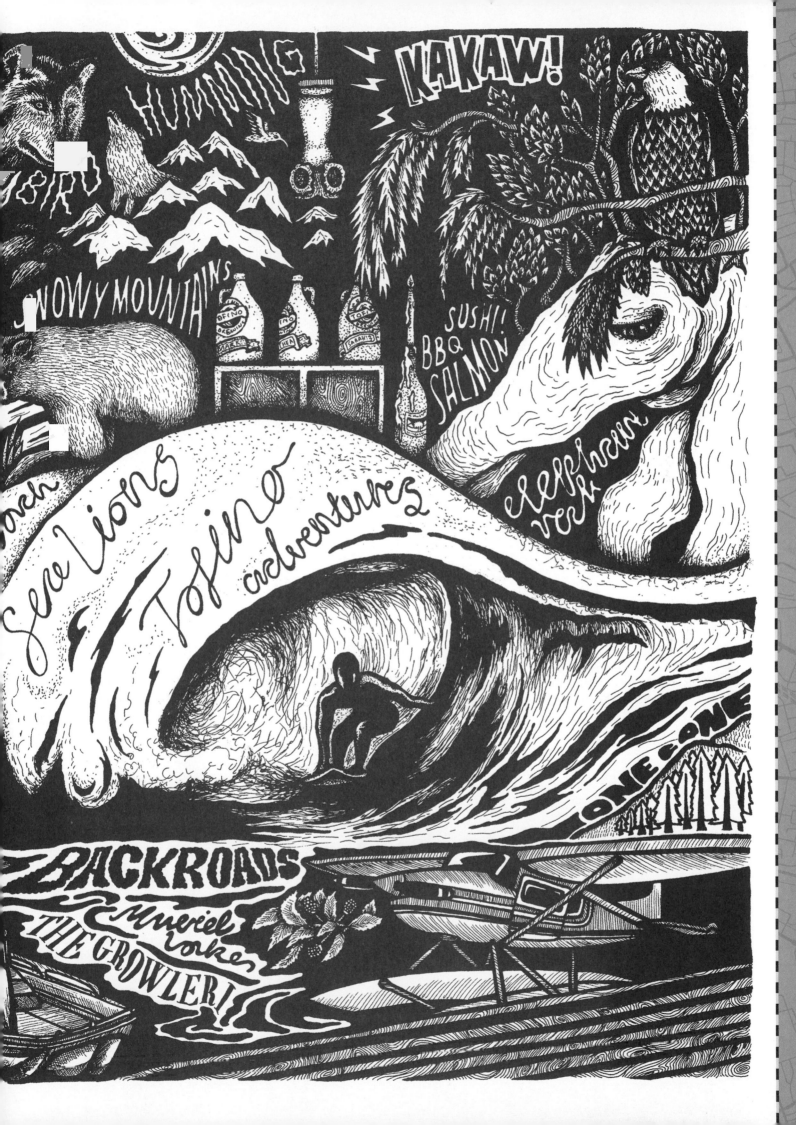

ABOUT THE ARTISTS

JAMES GULLIVER HANCOCK

James Gulliver Hancock feels sick when he's not drawing. He panics that he may not be able to draw everything in the world at least once. James grew up in Sydney, Australia, and studied visual communications at the University of Technology. James is a well-traveled illustrator known for his playful style. His obsession with drawing everything in the world has given him the opportunity to work on major projects around the globe; his work has appeared on billboards, TV commercials, ceramics, books, and board games. James has undertaken artist residencies all over Europe and, most recently, has been living in New York City. Visit www.allthebuildingsinnewyork.com.

HENNIE HAWORTH

Illustrator Hennie Haworth lives in London with her partner, two children, and little dog called Basil. She studied at Brighton University and went to Minneapolis for a semester. Upon graduation, she started out as a freelance illustrator. Her first job was designing children's bedspreads for Habitat—a retailer of household furnishings founded in 1964 by Sir Terence Conran. Hennie loves drawing buildings, clothes, patterns, food, maps, type, and anything colorful! Hennie's tools of choice include a combination of pens, pencils, chalks, and inks. She spent six months in Japan drawing a collection of vending machines; they were all over the place and always had both hot and cold drinks available. Visit www.henniehaworth.co.uk.

STUART HILL

Stuart Hill is a freelance illustrator and designer from the flat lands of Lincolnshire in the United Kingdom (which might explain his deep fear and fascination with mountains). Stuart specializes in logo design, editorial illustrations, and mapmaking. He studied Illustration at the University of Lincoln and graduated in 2014. Stuart likes printed textures, handmade type, and riding his bike. He loves touring with his bicycle, and his favorite adventure has been a week spent cycling down the coast of France with his best friend. They covered more than 300 miles (see page 58). Stuart's work has been featured in several books and magazines, as well as on the Behance curated gallery. Visit www.stuarthillillustration.com.

SARAH KING

Sarah King grew up in London, England. She studied graphic design at the University of Brighton and now lives in Tofino, Canada. Her interest in graphic design, illustration, and language has inspired the shape-forming typography that she now often uses in her work. After graduating in 2008, Sarah traveled to New York to intern with illustrator Michael Perry. She returned to London later that year and joined Studio Open: a creative workspace filled with an inspiring group of artists and designers. After several years of illustration and travel, Sarah visited British Columbia, Canada. She fell in love with the country and moved there permanently in 2011. Visit www.sarahaking.com.